SHORT CUTS

INTRODUCTIONS TO FILM STUDIES

NEW DIGITAL CINEMA

REINVENTING THE MOVING IMAGE

HOLLY WILLIS

WALLFLOWER

LONDON and NEW YORK

A Wallflower Paperback

First published in Great Britain in 2005 by
Wallflower Press
4th Floor, 26 Shacklewell Lane, London E8 2EZ
www.wallflowerpress.co.uk

A catalogue record for this book is available from the British Library

ISBN 1 904764 25 8

Book Design by Rob Bowden Design

Printed in Great Britain by Antony Rowe Ltd, Chippenham, Wiltshire

CONTENTS

ACKNOWLEDGEMENTS

This book marks the culmination of several years of writing, interviewing and research. For part of that time I was editor of *RES Magazine* and co-curator of RESFEST, and I would like to acknowledge the support provided by the magazine, the festival and my colleagues, specifically Jesse Ashlock, Sue Apfelbaum, Sandy Hunter, Laura Kern, Karol Martesko-Fenster, Colin Metcalf, John Turk, Johnnie Scalise, Scott Smith and Jonathan Wells, as well as the design teams at Trollbäck and Stiletto. I would also like to thank the numerous contributors to the magazine, who helped create a dynamic context for the discussion of many of the issues and artists included here, and I would like to thank all of the filmmakers, artists and producers who shared their time and thoughts in interviews.

The book was also greatly influenced by several lectures and classes, and I would like to thank my students at the University of Southern California, California Institute of the Arts and Art Center College of Design for their input and feedback.

Finally, I offer thanks to my husband, Steve Anderson, who has been my creative partner in conversation, curating, writing, editing and teaching, helping make the ongoing investigation of moving image art always vibrant.

INTRODUCTION: EXPLODING CINEMA

'Cinema is dead; long live cinema.'[1]

Peter Greenaway's characteristically provocative declaration embodies a common theme winding through contemporary cinema around the turn of the millennium in which the advent of digital video technology was seen as at once an end and a beginning. Countless pessimists have bemoaned the passing of 'real' film, while as many champions of digital video have heralded the advent of a new, democratised form of filmmaking, one that will release us from the tyranny of the Hollywood film industry and the pitfalls of the massive consolidation of media within a few transnational corporations. Euphoria butts up against fear in innumerable assertions of a new era, echoing in some ways the utopian excitement and turmoil surrounding the advent of cinema at the turn of the last century.

That said, advocates of video art have also fretted over – and celebrated – the dissolution of their medium. Critic and curator Michael Nash, for example, opens his 1996 essay 'Vision After Television: Technocultural Convergence, Hypermedia and the New Media Arts Field' by declaring that 'the least that can be said is that we have witnessed the death of video art in the United States' (1996: 383). He goes on to note that 'distinct philosophical and stylistic shifts have muted the dichotomy between video art and television', and indeed, that 'the media revolution is to some extent being televised or looks like television, and the battle lines are completely blurred' (1996: 382–3). He attributes the diffusion of media specificity in part to new forms of criticality, in which media art forms are just as much

media critical forms, namely forms that eschew the distinction between artwork and criticism. In short, a sense of hybridity in video art in the early 1990s led to 'critical television, metacritical media and activist advocacy' (1996: 383), while once dedicated 'video' artists eagerly adopted film as their medium if it would foster their needs regarding distribution and exhibition. Nash sums up: 'It was said a decade ago that video art may have been the only art form to have a history before it had a history, and now its history is *history* before we had a chance to mourn its passing' (1996: 382).

On the one hand, Nash and Greenaway's proclamations, and similar announcements of beginnings and ends, obscure the blurring of disciplinary boundaries and medium specificity that began with the advent of consumer-level video technology in the late 1960s and the evolution of computer technology that contributed to increasingly elaborate computer-generated imagery in Hollywood feature films from the early 1970s onward. They also downplay the fact that these alleged boundaries, while maintained on institutional levels and in the work of many individual artists, have nevertheless always been to some extent quite fluid. Artists have often worked in both film and video – even Nam June Paik, often celebrated as one of the first artists of video, also worked in film, and Bill Viola, another celebrated icon of the video art realm, in his later career has been creating complicated projects in 35mm that in their production process, with elaborate sets, casts and crews, are more akin to extravagant Hollywood film productions than the typical video art creation. Similarly, filmmakers known for their dedication to examining the fundamental components of cinema, such as Jean-Luc Godard, have also worked in video. And Francis Ford Coppola championed not only the merits of video production, but the creation of entire 'electronic studios' in the early 1980s when he purchased the old Hollywood Center Studios on Las Palmas Avenue (coincidentally just down the street from Kodak's Hollywood office), where he created large-scale stages for the production of *One From the Heart* (1982), his first experiment with an 'electronic' mode of filmmaking. Speaking loudly and frequently, Coppola was certainly the most visible proponent of video as a tool for feature-film projects, and prophesied an imminent – and radical – shift in the ways that films would be made. And finally, since the early 1980s and the incorporation of increasingly transparent computer-generated visual effects, and

the early 1990s, when the majority of Hollywood feature projects shot on 35mm have undergone a digital intermediate process when the film stock is digitised and then edited and altered in extensive digital post-production before being output again to 35mm as a 'film', film and video have, despite claims to the contrary, merged. Indeed, computers and digital technologies have so deeply affected both contemporary culture at large and image-making processes in particular that to speak of film or video as a 'pure' medium is next to impossible. To bemoan the eclipse of film, then, is to mourn a phantom while ignoring what Nash has termed a 'millennial vortex', one that 'is almost incomprehensibly large and powerful, a crush of convergences of the largest information systems in the world' (1996: 383).

Rosalind Krauss seconds the notion, articulating what she dubs the 'post-medium' in her extended essay '"A Voyage on the North Sea": Art in the Age of the Post-Medium Condition'. She writes:

> Television and video seem Hydra-headed, existing in endlessly diverse forms, spaces and temporalities for which no single instance seems to provide a formal unity for the whole ... Even if video had a distinct technical support – its own apparatus, so to speak – it occupied a kind of discursive chaos, a heterogeneity of activities that could not be theorised as coherent or conceived of as having something like an essence or unifying core ... It proclaimed the end of medium-specificity. In the age of television, so it broadcast, we inhabit a post-medium condition. (1999: 31)

While we may inhabit a post-medium condition, we also inhabit a world in which Hollywood cinema is first and foremost a business, one facing serious financial challenges brought about in large part by digital technology. Indeed, the availability of consumer-level digital video cameras and desktop editing software tools in the mid-1990s, along with the growing capabilities of Internet streaming and the gradual convergence of media screens, have marked a considerable shift in cinema, not just in the United States but internationally, and not only in terms of mode of production, but in regard to distribution and exhibition as well. The changes are widespread and include shifts in industrial practice and cinematic tropes within Hollywood, as well as the evolution of national cinemas heretofore

prevented from establishing a prolific film culture; a resurgence of interest in large-scale film and video installations in galleries and museums as film and video converge; an increasing use of live video sampling tools in club events; a renewed independent film movement featuring narrative experimentation, low-budget modes of production and, on occasion, a focus on overtly personal or political issues; a reinvestigation of the goals and projects of the classical avant-garde; the advent of 'digital graffiti'; and a growing media-based culture not beholden to the constraints either of the feature narrative form, nor even of the movie theatre. Indeed, Peter Greenaway's work offers just one example of these shifts – the director's project titled *The Tulse Luper Suitcases* (2004) is composed of three feature films, 92 DVDs, an online game, a television series and numerous museum shows in a massive artwork that explodes well beyond the boundaries of traditional cinema to exploit a variety of screens and exhibition formats.

This book sketches some of the shifts that have taken place over the last decade in conjunction with the rise of digital filmmaking tools and the evolution of a new form of moving digital media art, one situated at the intersection of the formerly separate realms of filmmaking, music video, animation, print design, live club events and video art. Beginning with the premise that we are witnessing the most extensive reworking of the role of images since the inauguration of cinema, the book opens with an investigation of innovations in the feature film format. Rather than chronicling the use of computers and technology in studio films, however, it examines independent, art-oriented experimental efforts, including animation/live-action hybrids, the gritty aesthetic adopted by the Dogme 95 filmmakers and the explosions of frames within frames, layering and the evolution of what might be dubbed a 'desktop aesthetic'. Indeed, the work of innumerable artists exploring the parameters of film and video has created an extensive moving image discourse unparalleled in the history of cinema; this work appears online, in museums and galleries, and on the streets in a tremendous variety of practices and with an equally abundant number of mandates. The book then moves on to examine the emergence of these new genres and moving image experiences as what we know as cinema expands beyond the confines of movie theatres and television screens into new venues, transforming the activities of everyday life and asserting the primacy of media culture.

Digital defined

What exactly does the word 'digital' in 'digital video' mean and how does it differ both from film and from analogue video? The first answer has to do with a distinction between transcription and conversion. With a film camera, a cinematographer simultaneously captures and records light as it comes through the lens and strikes the emulsion of each frame of cel-luloid, where it activates silver halide crystals, leaving a material imprint of the profilmic event on the film stock. For some, including film scholar André Bazin, film and this direct relationship to the world in front of the lens supports not only a philosophical agenda that champions the ability of film to reproduce the world, but also reinforces a general – and contro-versial – supposition that we *can* represent reality.

With analogue video, the recording of images is quite different. Rather than hitting emulsion, light strikes a sensor, such as a cathode ray tube (CRT) or charge coupled device (CCD), which momentarily captures a rep-resentation of the light. The camera then transmits an analogue signal, which is composed of continuously varying waveforms that create analo-gies of patterns that are then changed into other states, such as electrical signals, which are collected and held on magnetic tape.

With both film and analogue video, then, the information we experi-ence in its final form is analogous to the information in its original form. A transfer occurs between the original information and the recording of that information. As Timothy Binkley explains in an essay titled 'Refiguring Culture', 'until recently, media have conformed to what is called an ana-logue paradigm characterised by an imprinting process. Analogue media store information through some kind of transcription which transfers the configuration of one physical material into an analogous arrangement in another' (1993: 94). He goes on to note that analogue media are displayed either directly, as with a photograph, or through some form of display, which adds another instance of transcription:

> By transferring reflected light onto reflective pigment, a camera
> generates visible film whose recorded images are simply looked
> at. But when light patterns are embedded in an electrical signal
> by a video camera, the analogous forms imparted to the current
> are not visible until they are transcribed back into light as glow-

ing phosphor on a monitor. When a video signal is recorded on tape, yet another transcription imprints electrical impulses onto analogous magnetic ones, and the playback process involves two transcriptions that first conform electric current to the recorded magnetic fields and then match the flicker of light on the screen to the varying flow of electrons. (1993: 96)

The implications of this process of transcription may be seen most clearly with regard to the generational loss experienced through duplication. Each time analogue video (or photochemical film) information is copied, some of the original fidelity or precision is lost in the process of transcription, causing image quality to suffer and limiting the number of copies that can be made.

With digital video, however, the process is fundamentally different. Rather than transcription, information recorded with digital video goes through a process of conversion. A digital camera does not record an analogue signal of continuously varying voltages but instead a series of zeroes and ones in a pattern of relationships defined by mathematical algorithms. As Binkley explains, 'Whereas analogue media store cultural information in the material disposition of concrete objects, digital ones store it as formal relationships in abstract structures' (ibid.). Thus, in general terms, 'digital' refers to data that exists as a series of discrete elements, arranged in mathematically determined patterns. As a result, digital information may be endlessly duplicated, manipulated and transformed without generational loss or degradation of quality. The quality of a digital image, then, is determined not by a fixed number of 'dots' per inch or lines of resolution but by the efficiency with which the digital processor can convert visual information to patterns of ones and zeroes. This is determined by both the rate at which the digital information is sampled and the degree of compression to which this information is subjected before it is stored.

Analogue video first became available as a format for artists in the late 1960s, when Sony created the portable Portapak cameras adopted by artists as varied as Nam June Paik, Vito Acconci and Joan Jonas. While the artworks created with the disparate video formats since 1968 form a fascinating body of work, editing video was a difficult and imprecise two-step process (offline and online). In the early days of video, online editing entailed working with expensive equipment not readily available

to individuals; network television producers established standards that prohibited the broadcast of footage deemed less than professional grade, thereby relegating video imagery produced with lower-end equipment to alternative screening venues. Video art, too, despite several early TV experiments, rarely found its way to television, appearing instead in galleries and museums. This, coupled with problems of generational loss in analogue video, led to a strict division between commercial/professional video practice and that of artists and so-called amateurs.

While analogue video entails grappling with these often difficult challenges, digital video obviates them by offering greatly increased fidelity and malleability. Whereas an analogue signal degrades not only during transmission but with each duplication, digital signals may be altered and reproduced by artists using equipment which rivals the final quality of professional and commercial production.

But why is this important? To say that we inhabit a digital world is an understatement. Since the early 1990s, digital image production, as well as the Internet and other information technologies, have radically altered some of the most basic aspects of our daily lives: how we communicate; how we share ideas and images; how we buy things; and how we understand notions of community. More specifically in terms of media production, digital video means that the quality of the image signal, long a barrier of access to exhibition outlets, drops away. And in terms of reproduction, digital tools allow for the theoretically infinite reproduction of material with no loss of quality, affording new modes of production based on appropriation and sampling, and indeed, contributing to a culture of sharing and recycling.

Computers and cinema

Digital video is only one half of the digital filmmaking revolution, however. The other half is computer technology and the advent of desktop editing and visual effects tools that allow filmmakers to edit, animate and otherwise alter digital footage on their own computers, thereby eradicating the prohibitive expense that characterised video editing and effects in previous decades.

Macintosh computers were introduced in 1984, and were significant in being the first personal computers designed with a graphical user

FIGURE 1 *Flux* (1999), a short film by Michaela French, includes frames within frames and many layered images

interface. Software applications such as Adobe Premiere (first introduced in 1991), and Final Cut Pro (introduced by Apple in 1999) allow relatively easy desktop editing, but more significantly, they dramatically alter the ways in which editors can work with sequences of images. Adobe After Effects, introduced in 1994, allows filmmakers to create special effects and title sequences; Macromedia Director (originally titled VideoWorks Interactive Pro) was introduced in 1988 and quickly became the primary tool for authoring interactive CD-ROMs, and Macromedia Flash, introduced in 1996, lets filmmakers create scalable animations that use vector-based images created with algorithms rather than bit-mapped images made with pixel maps. Not only do these tools allow for what has been variously dubbed 'garage' and 'desktop' filmmaking, but they alter modes of production and aesthetics as well. Indeed, in examining American independent filmmaking across the 1990s, it is possible to chart a shift in emphasis from production to post-production, from cinematography and lighting to editing and special effects. Filmmakers are also able to practice much more readily, shooting their projects for far less expense, and then taking more time to edit on their home equipment. The number of feature films produced annually has grown exponentially, as has the number of short films, in both live-action and animation, as well as music videos and design-oriented projects.

The changes in image-making, and the promulgation of fantasies that has accompanied them, have been charted in a handful of magazines, such as *Wired*, *RES*, *Filmmaker* and *The Independent*, all of which champion the role of the consumer as producer, with an emphasis on behind-the-scenes how-to information that contributes to a production-oriented cinematic culture. Rather than passively receiving images, these publications suggest, we can now more readily engage in the production of images. The accompanying sense of moviemaking literacy and empowerment, while indisputably circumscribed by the overwhelming power of mainstream media, is nonetheless characteristic of a remarkable transformation in our fundamental relationship to moving image culture.

In some ways, these shifts seemed to answer the needs of both film-makers and video artists, many of whom from the 1960s forward had been working extensively with layered and collaged imagery and text – with all the concomitant intricacies and expenses of time – as well as on small-scale or documentary productions inhibited by large, bulky cameras. Therefore, the smaller cameras, higher quality images and the ability to shoot in low-light situations offered by digital video were more than welcome, as were the easy-to-use basic effects software programs that allow the use of text, layering and the compositing of images.

While these computer-based tools have prompted a dramatic shift in independent filmmaking, the intersection of film, video and computer technology has been around for decades. Filmmaker John Whitney, for example, began experimenting with sound and moving images in the 1940s, and was driven by the parallel desires to work with the tools of mechanical engineering to create abstract visuals that would be a form of visual music. A self-described college drop-out, Whitney asks, 'How could I be interested in telescopes and motion picture cameras and be so deeply moved by music and art?' (quoted in Furniss 1994: 19). Over the course of his remarkable career, Whitney answered that question. He founded a company called Motion Graphics Incorporated in the 1960s and IBM hired him as its first artist-in-residence, where he investigated ways of melding computers, graphics, typography and music. While Whitney confesses to having little interest in cel animation or even working frame-by-frame with a movie camera, he did make a series of animation machines, or 'mechanical systems that would manipulate' (Furniss 1994: 18). He documented these devices in a film titled *Catalog* (1961) and upon completing

the film, realised that he had been trying to invent a computer: 'I began to fully realise that all these mechanical systems were just a tedious way of doing something that could be done absolutely in a perfectly natural way with computers and computer graphics' (ibid.). Whitney eventually created a computerised drawing machine that led to the development of a fully automated system involving high-precision integrated coordination and control of the entire production process. In interview, Whitney claims that his 'mechanical film machines' were the forerunners of motion control and slit-scan techniques, both of which were used on Stanley Kubrick's *2001: A Space Odyssey* (1968).

Whitney's contributions to the history of cinema are broader, how-ever, in that he helped develop 'visual music'. Extending the projects of filmmakers as varied as Hans Richter and Viking Eggeling in the 1920s and Oskar Fischinger from the 1930s, Whitney used his computerised machines to seek ways of creating a direct correlation between music and its visual expression; his best-known film is the seven-minute *Arabesque* (1975), which includes computer-controlled motion to create precise abstract patterns. Whitney also worked with other filmmakers who shared his interests, including his brother, James Whitney, Jordan Belson, Harry Smith, Ed Emshwiller and Stan Vanderbeek, as well as numerous musi-cians. Emshwiller is perhaps best known for *Sunstone* (1979), which incor-porates colour-cycle animation (a technique in which the colours of an image shift) and texture mapping (when a two-dimensional image, often one that represents a texture, is laid over a three-dimensional object). And Vanderbeek worked on early computer/film projects at Bell Labs with Kenneth C. Knowlton, including *Poem Fields* (1964–70), a series of eight films that are abstract, animated mosaics.

Beyond contributing to one of the most compelling bodies of work in the history of experimental cinema, the projects collected under the rubric of visual music are significant in envisioning alternative models of cinematic expression. As Whitney states:

> The entire Hollywood industry, all through that time and to this very day, is interested in one thing and that is making the face the right colour and absolutely convincing you of a faked reality ... So all the energy and the terrific ingenuity goes into special effects: faking, creating, falsifying or recreating a reality'. (in Furniss 1994: 16)

In contrast, Whitney wanted to create an abstract moving image artform. 'We are immensely moved by the abstract structure of melodic patterns. We hear them and they mean a lot to us' (ibid.).

One of the attributes of much of this early work was the exploration of consciousness, charted by Gene Youngblood's 1970 book *Expanded Cinema*, a fervent tribute to the evolution of a utopian cinematic practice that would expand consciousness through the creation of immersive, kineasesthetic/synaesthetic film-viewing environments. Youngblood's book charts several disparate instances of this sort of filmmaking, all of it designed to expand consciousness. He develops the notion of a synaesthetic cinema, calling it a 'major paradigm of cinematic language' (1970: 82). He writes: 'Synaesthetic cinema is an art of relations: the relations of the conceptual information and design information within the film itself graphically, and the relation between the film and viewer at that point where human perception (sensation and conceptualisation) brings them together' (ibid.). He continues, explaining that this cinema often fuses 'inside' and 'outside' by reducing depth of field to create a 'total field of non-focused multiplicity' (1970: 85), and insists that by 'creating a new kind of vision', this synaesthetic cinema 'creates a new kind of consciousness', namely 'oceanic consciousness' (1970: 92).

Computer-generated imagery in Hollywood

Countering the utopian goals of Youngblood and artists interested in expanding consciousness, studio-oriented filmmakers began to incorporate computer-based imagery into Hollywood films with the goal of creating worlds that were at once fake and 'real'. The goal was to replicate realistic worlds through artifice, and to make the use of computer-generated effects as transparent as possible. Early experiments in this area included films such as *Westworld* (Michael Crichton, 1973), which contains two minutes of computer-generated imagery created by John Whitney to convey a robot's point of view. In *Alien* (Ridley Scott, 1979), a wireframe contour map of a planet's surface was integrated into the film, showing – with a computer – how a computer allowed the spaceship's team to maneuvre through space. The image – a glowing, green grid – became a visual trope, and innumerable films would follow suit, including *Blade Runner* (Ridley Scott, 1982), demonstrating within the narrative, and often quite pre-

sciently, the abilities of computer imaging to overcome the limits of two-dimensional representational space. *Tron* (Steven Lisberger, 1982) was another landmark in the evolution of computer-generated imagery, and like *Alien*, helped establish another trope. In several sequences, we follow a character's trek inside a computer; these scenes were designed to look like early video games, and were created by dressing the actors in white costumes overlaid with black grids; the actors were photographed against a black background, and then the frames of that footage were transferred to transparencies and animated on an animation stand, where the actors' faces were left intact while their bodies became illuminated cartoon-like figures against a computer-generated background. In total, the film had 16 minutes of computer-generated imagery; unfortunately, the film failed at the box office, and computer-based effects were deemed both expensive and risky.

Star Trek: The Wrath of Khan (Nicholas Meyer, 1982) and *The Last Starfighter* (Nick Castle, 1985) both incorporated computer-generated effects to augment the production design that built a fantasy realm. In *The Abyss* (1989), James Cameron, who would become one of Hollywood's chief advocates of digital effects with the founding of his company Digital Domain in 1994, used computer-generated shots to show the pod that moves through the watery underworld that comprises the film's main setting. The challenge for the effects team was to create the undulating fluidity of wave patterns on the pod's reflective exterior, which was achieved by writing a special software program. Cameron continued his use of computer technology on *Terminator 2: Judgment Day* (1991) when morphing was used to create a smooth transition between the body of a robot and his human-like exterior in a process film scholar Vivian Sobchack has analysed as at once utterly familiar through overuse in films and television commercials and at the same time fascinating and deeply *unheimlich*. She writes of the fascination inspired as the elasticised bodies metamorphose, transgressing the body's boundaries.[2] *Jurassic Park* (Steven Spielberg, 1993) pushed the envelope further by featuring entirely digital dinosaurs wreaking havoc in the 'real' world of the story, and *Toy Story* (John Lasseter, 1995) became the first entirely computer-generated feature-length animated film.

In the flurry of digitally enhanced feature films that emerged during the 1990s, several illustrated or fomented the burgeoning cultural hopes

and anxieties wrought by the intersection of computers, image production and the real. Robert Zemeckis' *Forrest Gump* (1994), for example, melds archival footage and composited live-action footage so that Tom Hanks, as the charming eponymous simpleton, is digitally inserted into innumerable historical moments, standing side-by-side with figures such as John F. Kennedy and Richard Nixon and becoming the hapless instigator of many of America's best-loved cultural trends. The celebrated film is a tour of American pop culture of the 1960s, 1970s and 1980s, and fosters American myths of heroism, ingenuity and class mobility. The film grossed over $300 million domestically, and played in first-run theatres for more than 18 months, earning Best Picture, Best Director and Best Actor Academy Awards. Thanks in part to the film's lighthearted humour, *Forrest Gump*'s manipulation of historical images ends up being reassuring rather than threatening, and the film's assumption that viewers will not confuse the 'real' with the 'fake' contributes to what Vivian Sobchack describes as 'a qualitatively new self-consciousness about history'. Further, appearing not long after Gulf War I, the film metaphorically presents America as an innocent participant in history, redeeming various decisions of the past by showing not only their origin in well-meant intentions but their lack of guile as well. Similarly, the conflation of 'real' and 'fake' imagery generates a pleasurable celebration of ingenuity and guilelessness that helped ameliorate a nascent uneasiness, both within the Hollywood film industry and American culture generally.

If *Forrest Gump* assuaged anxieties, the following year ushered in a slew of bad dreams chronicling a decidedly darker vision of the future-become-present. Kathryn Bigelow's *Strange Days* (1995), set on the eve of the millennium, tells a very dark, violent story about the buying and selling of memories and experiences, while *Virtuosity* (Brett Leonard, 1995), about the fashioning of an ultimate cyborg criminal in virtual reality who enters the real world, continues a longer tradition of machines-run-amok. *The Net* (Irwin Winkler, 1995) grapples with identity theft and the prospect of total surveillance, while *Hackers* (Iain Softley, 1995) embodies the fears inspired by the corporate control of information systems.

These films also suggest some of the anxieties of the Hollywood film industry, which in the mid-1990s faced massive change as the significance of digital technology gradually dawned on producers, distributors and exhibitors. Not only would a full transition to digital technology be exorbi-

tantly expensive, but all aspects of the industry were being threatened with dramatic transformation.

If 1995 witnessed an array of dystopian visions of the future, it was also the centre of innumerable utopian visions, too. At this point, computers, consumer-level digital video cameras and non-linear editing tools converged into a workable system available to the general public that began to affect cinema in terms of hands-on production for independent filmmakers. Cultural critic and founder of MIT's Media Lab Nicolas Negroponte compiled a series of essays from his contributions to *Wired* magazine under the title *Being Digital*, helping articulate the hopes and anxieties that accompanied the wider implications of digital technology.

Also, 1995 witnessed the creation of the Dogme 95 movement as a group of Danish filmmakers aligned with filmmakers Lars von Trier and Thomas Vinterberg and their 'Manifesto' and 'The Vow of Chastity'. Taken together, the documents counter 'certain tendencies' of contemporary cinema, proposing to combat 'the film of illusion' by adopting a series of 10 restrictions designed to pare filmmaking back to its essentials. While rule number 9 states, 'The film format must be Academy 35mm', Vinterberg's *Festen* (*The Celebration*, 1998), the first official Dogme film, was shot on miniDV, and indeed, subsequent Dogme films adopted the low-tech, low-cost format with gusto.

It is also important to note that by 1995, 81 per cent of American homes had VCRs and two-thirds of American homes had cable. Viewers were reconvening around their televisions, a fact that Hollywood had to account for, but more importantly, this was the site where independent filmmaking could go as filmmakers began discovering desktop filmmaking tools and the significance of the Internet, not only for sharing information, but more importantly for distributing and exhibiting their work.

Post-classical Hollywood and independent filmmaking

It is impossible to think about changes in recent filmmaking without situating them in a larger milieu of the 'New Hollywood', which refers to the economic revival of Hollywood filmmaking that began in the mid-1970s. The movement was led by a new generation of directors, including Steven Spielberg, Francis Ford Coppola, Martin Scorsese and George Lucas. The era inaugurated new marketing strategies, with a focus on the blockbuster

and high-concept films. The 1980s saw radical shifts in the ownership of Hollywood studios, and the consolidation of assets and power by larger corporations, along with the deregulation that allowed studios to own all aspects of the cinematic experience. These factors combined to make the 1980s in Hollywood the 'corporate era'.

An alternative response came from filmmakers such as Jim Jarmusch, Richard Linklater, Wayne Wang and Spike Lee, who sparked an independent film movement that would burgeon in the early 1990s. The films that comprise this movement reinvigorated both a visual style, celebrating the hand-made, and a narrative focus that was often about the everyday. A wave of independent feature films followed, and for nearly a decade there was a steady flow of films that eschewed the blockbuster style prevalent in Hollywood, while also contributing to a new wave of alternative distribution companies and exhibition spaces. Independent filmmaking functioned in part by exploiting market segments left untouched by the majors, and in part by exploring subject matter ignored by the studios and operating outside the realm of the majors in terms of distribution. However, both the aesthetic and institutional alternatives were quickly subsumed by the studios, and the movement began to dissipate as filmmakers were encouraged to repeat themselves, or to assuage the interests of the studios who would distribute the films. The films became commercial aspirants, and independent cinema became known as 'IndieWood'.

The movement's chief narrative was the rags-to-riches story about a boy who made a movie for no money and went on to make millions at the box office. It is the perfect American story, and the narrative not only fueled the fantasies of innumerable would-be filmmakers, but made overt the intersection of filmmaking and the market, giving the public a very tantalising embodiment of one of the most American of mythologies, namely that anyone can become rich and famous, but it added the stock market gamble, and hitting the jackpot, as added bait.

By 1997, the American independent film movement was, in the minds of many critics, on the decline, just as the advent of new video cameras and software as well as the rising significance of the Internet began to take shape. With the arrival of these new tools came a different kind of artist and people from all kinds of backgrounds began making movies; artists from the worlds of comic books, sculpture, graphics, design and drawing could bring their skills to filmmaking, and similarly, filmmakers who had

never used special effects or who had never tried animation, could suddenly play with new tools. The impact has been radical, both in terms of new methods for sharing and viewing films and in terms of aesthetics. The next chapter will discuss this impact in detail.

In terms of exhibition, the number of film festivals in the United States grew exponentially, reinvigorating nascent regional film communities and a circuit of alternative exhibition venues. Digital distribution is evolving as well. *The Hollywood Reporter* notes that the first commercial exhibition of a digital feature film using digital projection took place on June 1, 1999, when *Star Wars: Episode I – The Phantom Menace* was screened using Texas Instruments' DLP projectors at six venues across the US, while a prototype Hughes/JVC video projector screened *The Phantom Menace* at the annual ShoWest convention. *Jurassic Park III* (Joe Johnston, 2001) was screened the following month at Universal Studios using THX Digital Services, which compressed and burned the film onto 13 DVD-Rs and loaded them onto servers in each theatre.

Video and DVD rentals have also changed the distribution and exhibition landscape dramatically. Rentals increased precipitously, and in 2003, the Consumer Electronics Show reported that the fastest growing segment of the consumer electronics realm was home theatre equipment, pointing to an increasing desire to create spaces within the home designed specifically for 'theatre-style' viewing. This is not the first time that viewers have wanted to stay home, to be sure – the arrival of television stimulated a parallel trend in the 1950s. Finally, growing bandwidth has contributed to an increase in online film viewership, from short films to features, with sites such as iFilm and Atom Films allowing viewers to download and watch films over the Internet.

Film and video have also re-emerged as central components in the revitalisation of the museum and gallery world. In 2002, Bill Viola's 13-minute video installation 'Five Angels for the Millennium' earned $700,000 when it was jointly purchased by The Whitney, Tate Modern and Pompidou Centre; Viola also has enjoyed numerous major exhibitions in the last decade, with shows at the Guggenheim, San Francisco MOMA and various international venues, making him the star of a rapidly changing art scene, one much more ready to embrace video and its spectacle as the museum's cultural status faces decline. Indeed, in describing new cinematic developments, as Mark Nash points out, we must speak of multiple cinemas.

He writes, 'The history of cinema in the twentieth century is a history of a plurality of cinemas' (2002: 129). And thus it is important, too, to consider moving image installations which, rather than deriving from the history and concerns of sculpture, instead grapple with notions of spatiality and temporality as they derive from filmmaking, and the desire to explode the traditional apparatus of cinema, to spatialise it and disrupt typical modes of spectatorship and identification. The Whitney Museum of Art's large-scale exhibition titled 'Into the Light: The Projected Image in American Art 1964–1977' (18 October 2001 – 6 January 2002) helped created a historical context for much of this work. Similarly, Matthew Barney, with his five-part *Cremaster* epic (1994–2002), blasts beyond the confines of the movie theatre with the final iteration of the project being its extension as an exhibit and large-scale screening in New York's Guggenheim museum in 2003, where the controversial artist also shot the film, thereby layering the project's production and exhibition sites.

Theoretical reflections

The shift from analogue to digital has provoked numerous philosophical responses, as well as attempts to situate digital media technology historically with a new vocabulary of terms. Anna Everett and John T. Caldwell's term 'digitextuality', for example, combines the ubiquitous term 'digital' with Julia Kristeva's notion of intertextuality as defined in her book *Revolution in Poetic Language*. Everett draws from Kristeva's description of every text 'as a mosaic of quotations' and as a process of 'absorption and transformation of another text' in order to describe the process in new media by which old media are transposed into new forms (2003: 7). She writes:

> Where digitextuality departs from Kristeva's notion of intertextuality is that the former moves us beyond a 'new signifying system' of quotations and transpositions, to a metasignifying system of discursive absorption whereby different signifying systems and materials are translated and often transformed into zeroes and ones for infinite recombinant signifiers. In other words, new digital media technologies make meaning not only by building a new text through absorption and transformation of other texts, but also by

embedding the entirety of other texts (analogue and digital) seam-
lessly within the new. (ibid.)

Jay David Bolter and Richard Grusin also consider the intersection of media
forms, but along a timeline, using the term 'remediation' to suggest that
new media and our relations to them are patterned on the familiar forms
and relations of old media. Lev Manovich uses the term 'transcoding' as
a way of noting that computers and culture are constantly changing each
other. And Aaron Betsky uses the notion of the 'recursive':

> What is remarkable about digital code is its recursiveness. It
> reduces all that can be said or calculated to the combinatory pro-
> cesses of just these two signs for 'on' and 'off'. It produces out of
> them a set of projected images of which one cannot say whether
> they are real or not. What one can say is that they are purely the
> product of programming and exist only in that state of projection.
> (2001: 43)

And finally, the Critical Art Ensemble uses the term 'liquescence' as a
means for describing 'our present social condition'. They write:

> The once unquestioned markers of stability, such as God or Nature,
> have dropped into the black hole of skepticism, dissolving posi-
> tioned identification of subject and object. Meaning simultane-
> ously flows through a process of proliferation and condensation, at
> once drifting, shifting, speeding into the antinomies of apocalypse
> and utopia. (2000: 11)

Each of these terms points to a slipperiness – formal, conceptual and dis-
ciplinary – that is perhaps as contradictory as Peter Greenaway's hello and
goodbye that opened this chapter. Cinema may be gone, but, as the next
chapters will indicate, film, music and design are merging, and the 'direc-
tor' of the past is becoming a 'digitalist', someone attuned to the flow and
mix of codes on multiple registers.

1 THE FUTURE OF THE FEATURE

In 1976, French filmmaker Jean-Luc Godard began dreaming of a 35mm camera that would be small enough to fit into the glove compartment of a car. He wanted a camera, in other words, that he could cart along and use to shoot images spontaneously, as he came across them, rather than having bulky equipment determine the time and place of every filmed image. 'You're in Holland', he said in an interview in *Camera Obscura*,

> out in the country and you see a windmill that is completely motionless ... You take the camera out of the glove compartment, you shoot, and you get a 35mm image with the highest resolution possible in cinema or television. Suddenly you think of *Foreign Correspondent* (the sequence when the windmill turns the wrong way). Or of something else. Because you already have an image, and once you have an image, you do something else with it. (Beauviala and Godard 1985: 165)

The result of Godard's desire was a lengthy and contentious collaboration with Jean-Piere Beauviala, an inventor with Aaton, to try to create such a camera. They ultimately failed, but what Godard so nicely points out is that filmmaking equipment influences the kinds of images that can be made, as well as the ways in which stories can be told. For decades, filmmakers around the world have shared Godard's dream, fantasising what until recently was a filmmaking oxymoron: lightweight, portable cameras with high-quality image output – a camera that could be used to sketch with

first, offering the genesis of a film in a series of images that would then contribute to a story rather than the opposite, namely the imposition of a script as the foundation for the images, which are secondary.

In 1982, Francis Ford Coppola added another element to the filmmaking fantasy when he made *One From the Heart*, a feature-length narrative produced on the lot of Coppola's Zoetrope Studio and shot simultaneously on film and video, allowing Coppola to see immediately what he was filming, and even to begin editing the taped material. Coppola also used extensive amounts of composited imagery, as well as exaggerated lighting and effects. The film, a light-hearted romance starring Teri Garr, Raul Julia, Natassia Kinski and Frederic Forrest, certainly contrasts with the intensity of his earlier film, *Apocalypse Now* (1979), and for various reasons was a commercial failure. Coppola's venture was extensively documented in the mainstream press, however, with Coppola appearing on numerous television talk shows to advocate a new kind of filmmaking practice that would allow him to construct patently fake spaces, so that his story would not merely unfold against a backdrop, but that the image itself would become a layered construct, and the filmmaking process would expand to include the creation of hybrid spaces and the possibility of working with video images in real time. *One From the Heart*'s main strengths include its adamantly anti-naturalistic lighting design that underscores emotions and the intersection of spaces that are deliberately non-real with those that seem to be 'real'.

Coppola's experiments with spatial representation presaged one of the key tropes of feature-film experiments in digital video that would occur some two decades later. Further, in articulating his intentions for the project, Coppola described an 'electronic studio' of the future, a space he imagined within which filmmakers could create entire worlds divorced from the restrictions of Hollywood and the demand for a realist aesthetics. He also envisioned a democratised form of filmmaking that would give would-be filmmakers access to inexpensive cameras and editing supplies. And to make sure we all understood just how democratic his vision was, he conjured the image of a 'fat girl in Ohio' whose films would revolutionise filmmaking forever.

Notions of cinematic experimentation afforded by new cameras and video technology were continued to some extent with the advent of the PXL-2000 video camera, introduced in 1987 by Fisher-Price as a low-cost

video camera for kids. A small, plastic camera, the PXL-2000 records onto audiocassettes and produces an evanescent, grainy black-and-white image inside a black frame. The camera was adopted by artists such as Steve Fagin, Eric Saks, Michael Almereyda, Peggy Ahwesh and Sadie Benning, who appreciated the camera's chunky, high-contrast picture quality. Benning's work gained particular notoriety – she crafted a series of autobiographical video diaries shot in her bedroom in the late 1980s and early 1990s, and their intimate candor, deft use of music and surprising beauty catapulted the young artist into the international spotlight. Michael Almereyda used the camera, too, to shoot sections of his black-and-white feature film *Nadja* (1994), which was released in its final form theatrically on 35mm, while Ahwesh, in collaboration with Margie Strosser, made the epic *Strange Weather* (1993), a 50-minute fictional video that plays with our desire to know about illicit activity, as well as our willingness to hear a story – any story. In this case, the meandering activities of four crack-smoking youths are interrupted by a series of recounted anecdotes. In all of these examples, however, the key point is that despite the low-tech genesis of the images, they nevertheless harbour a surprising beauty, while the inexpensive mode of production contributed to a sense of casualness and ease that would have been quite difficult to achieve with expensive film running freely through a movie camera.

These examples sketch only a fragment of a very dense history, and indeed, the history of cinematic technology has never been simply a series of improvements in film stocks, sound recording devices, lenses and cameras, but instead a complex negotiation of ideological and economic concerns that has little or nothing to do with offering filmmakers more ways to make movies. Brian Winston, after chiding those who tout the advent of an 'Information Revolution', calling it 'largely an illusion, a rhetorical gambit and an expression of technological ignorance', argues instead that 'there is nothing in the histories of electrical and electronic communication systems to indicate that significant major changes have not been accommodated by preexisting social formations' (1998: 3). He proposes a model of technological change that insists on 'the primacy of the social sphere as the site of these activities, conditioning and determining technological developments' (ibid.). Examining patterns of innovation, repetition and diffusion, Winston borrows Ferdinand de Saussure's model of utterances to show how his model of technological transformation 'treats the historical

pattern of change and development as a field (the social sphere) in which two elements (science and technology) intersect' (ibid.).

Winston's caution is instructive, helping discourage us from the desire to trace the history of recent DV technology as a series of improvements in a continuous movement of progress. Instead, that trajectory includes delays, repetitions and diffusion, and occurs as the result of a complex interaction between the social sphere, science and technology. Indeed, as the electronic studio of Francis Ford Coppola so clearly suggests, what may seem like a relatively recent phenomenon, occurring mainly in the 1990s, has much deeper, often elided roots. Further, as with the PXL-2000 or even the use of 16mm, filmmakers often repurpose cameras and equipment designed for one use, and employ them toward other ends. Finally, cameras and other forms of cinematic technology never merely produce images; they also produce technologies of vision, some of which can expand cinema beyond the limitations of a Hollywood ethos. Whether it is the Direct Cinema movement of the 1960s spawned by crystal synch and the Éclair 16mm film camera, or the rich tradition of activist video made possible by the Sony Portapak, alternative camera technologies and the ways in which artists 'refunction' technology toward their own needs affect the nature and possibilities of filmmaking in a complex form of negotiation that is never seamless nor continuous, and may not necessarily lead toward improved capabilities.

The digital feature film

Rather than springing fully formed into life, Coppola's dream of an electronic cinema limped into reality over the course of 15 years. But it most certainly gained momentum with the advent of the miniDV camera and other tools of DV filmmaking. While many filmmakers long for the transparency of DV, when shooting on inexpensive digital video will not be readily apparent in the finished film, the most compelling DV feature-film experiments to date are those that work in the opposite direction, using DV to push against the confines of an entrenched realism. Some filmmakers cheerfully accept the degraded visual quality of miniDV as a trade for an increased sense of immediacy and intimacy, while others incorporate or even celebrate the image degradation, making it integral to their stories. Some have employed the low-tech equipment to help conjure stronger,

less forced performances, often from unprofessional actors, taking advantage of the possibility of shooting extensive footage inexpensively. DV has also been used to alter the traditional production trajectory, continuing the tradition inaugurated by Coppola in the creation of an electronic studio that allows for instant feedback. DV also encourages layering, frames within frames and the construction of spaces that meld live action and graphics or animation. And still other filmmakers have disrupted traditional notions of feature filmmaking by transferring their films to the web, in a sense spatialising their stories or, in some instances, creating forms of storytelling that diverge dramatically from the traditional feature-film format. And finally, others have taken advantage of the Internet and its abundant images to create a form of 'open source' filmmaking in which films are made from the surfeit of imagery available online.

It is impossible to view these developments in the evolution of digital filmmaking in isolation from Hollywood during the 1990s, as they constitute a very direct rebuttal to the film industry's corporatisation, as well as its defensive posture in response to digital technology. Hollywood grappled with anxieties regarding impending obsolescence with a spate of thinly-veiled allegories depicting the dangers of digital technologies in films such as *Jurassic Park*. As Paul Arthur notes in an essay charting Hollywood's narratives of looming disaster, 'It is entirely in the self-interest of commercial movies to capitalise on public fears of imminent catastrophe, to anathematise the spread of emerging technologies, and simultaneously to paint for itself a continuing role in a brave new world of image production' (2001: 344–5).

Independent filmmakers moved in two directions. First, what Peter Hanson has defined as the 'cinema of generation X', namely the group of filmmakers born between 1961 and 1971, shared several key experiences: they grew up during an incredibly tumultuous period which included not only the drug-related deaths of numerous pop idols and the murder of John Lennon but also the attempted assassinations of then President Reagan and Pope John Paul II. Additionally, this generation was inundated with pop culture more than any preceding generation and experienced immense social changes (including unprecedented levels of divorce). According to Hanson, youths responded by creating a culture characterised by irony, apathy and general disenfranchisement. Key filmmakers included in Hanson's Gen X filmmakers are Quentin Tarantino, Steven Soderbergh,

Robert Rodriguez, Paul Thomas Anderson and Richard Linklater, and the tropes of this cinema are multiple storylines, ironic humour, violence, an intense interest in pop culture and a general sense of excess in terms of images and information.

But more recently, with the ready availability of DV technology, many independent filmmakers have also advocated a return to the 'real', the organic and the authentic, deploying consumer-grade technology, often in movies centred on the search for connection and identity in a world amok with the invisible threats of surveillance, control and cyber-domination. So while Hollywood revealed its deep uneasiness over the imminent changes brought by DV technology, many independent filmmakers at that same moment celebrated emerging technologies while fostering activist positions of protest to sweeping annihilations of privacy. They also advocated a hands-on, do-it-yourself role that has expanded exponentially; consumers now not only programme their own television viewing with Tivos and their own music with iPods, but they create their own films, burn their own CDs and design their own DVDs. The degree to which our comfortable familiarity with video cameras and other forms of DIY technology only makes us more accepting of the tools of surveillance and corporate manipulation is up for grabs.

This chapter charts the impact of digital filmmaking tools on the feature film, beginning with the Dogme 95 movement, and moving on to detail a series of key projects made since 1995, arguing that the most compelling films of the DV era are those that employ new filmmaking tools to play with performance, design within the frame and entrenched ideas regarding realism.

Dogme 95 and the search for authenticity

Whether chastised as a publicity ploy on the part of provocateur Lars von Trier or celebrated as a bracing corrective to the shallow, manipulative and bankrupt cinema of Hollywood, the Dogme 95 movement garnered an inordinate amount of international attention almost from its inception. Written in March 1995 and presented at the Odéon Cinema in Paris by von Trier and co-conspirator Thomas Vinterberg, the rather poorly argued Manifesto begins by criticising the French New Wave: 'The New Wave proved to be a ripple that washed ashore and turned to muck', von Trier and Vinterberg

explain, adding that the movement gradually became 'bourgeois', because, they say, 'the foundation upon which its theories were based was the bourgeois perception of art'. Railing against the 'auteur concept', the Dogme 95 Manifesto further insists that filmmaking not be attributable to the individual, and that it not be used to create illusion: 'Dogme 95 counters the film of illusion by the presentation of an indisputable set of rules known as "The Vow of Chastity".' The set of 'vows' includes these 10 rules:

1 Shooting must be done on location. Props and sets must not be used.
2 Sound must never be produced apart from the images or vice versa.
3 The camera must be handheld.
4 The film must be in colour. Special lighting is not acceptable.
5 Optical work and filters are forbidden.
6 The film must not contain superficial action. (Murders, weapons, etc. must not occur.)
7 Temporal and geographical alienation are forbidden. (That is to say that the film takes place here and now.)
8 Genre movies are not acceptable.
9 The film format must be Academy 35mm.
10 The director must not be credited.

While Vinterberg and von Trier explicitly mention the French New Wave and an auteur-based cinema, the movement they are describing, if taken seriously, is most akin to the Third Cinema described by Fernando Solanas and Octavio Getino who, in their seminal essay 'Towards a Third Cinema', call for a cinema that will not be the cinema of Hollywood, nor a second cinema, namely that of the auteur, but a cinema composed of films that 'the System cannot assimilate and which are foreign to its needs or [that] directly and explicitly set out to fight the system' (1997: 43). One of the central goals of a Third Cinema was to create a collaborative practice, one that would de-individualise artmaking and dismantle traditional cinematic and artistic models of authorship and control. The extent to which that actually occurred in the Dogme 95 productions is negligible; indeed, we generally refer to the various completed efforts by the names of their directors.

Although rule number 9 asserts that 35mm film must be employed, Vinterberg, working with cinematographer Anthony Dod Mantle, shot

Festen, the first Dogme 95 project, on miniDV using an early Sony consumer-level video camera. The project was subsequently transferred to 35mm for theatrical release, and thanks to the dramatic intensity of the story and the urgent and vibrant cinematography, it became a rallying call for other filmmakers worldwide, many of whom – including Steven Soderbergh, Jordan Melamed and Harmony Korine – would cite the film as inspiration for their own DV feature efforts.

Vinterberg's story traces the ultimately explosive results of a family gathering in honour of the family patriarch's birthday. Secrets from the past are revealed, causing the already fragile group to implode. The film's formal style mirrors the story, discerning moments of roughhewn beauty within a new palette of cinematic colour and creating a surprising degree of intimacy via Dod Mantle's cinematography, which achieves imagery that hovers in style between the voyeurism of documentary and the seemingly innocent curiosity of home video. The film shared the Jury Prize in 1998 at the Cannes Film Festival, and was nominated for the Palme d'Or.

While the film on its own deserves attention, its performance in the marketplace was just as significant as its narrative and formal achievements. Indeed, many view the Dogme 95 brotherhood's greatest feat to be its rejection of the Hollywood budgetary imperative that demands

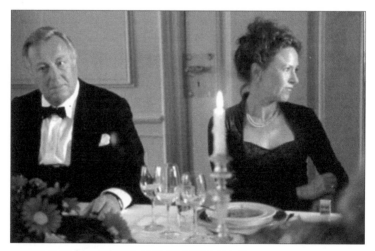

FIGURE 2 *Festen* (*The Celebration*, 1998), the first Dogme 95 film

that films worthy of theatrical audiences require not only a large budget for production, but an equally large – or larger – budget for advertising. Appearing well within the midst of Hollywood globalisation, then, the movement's impertinent dismissal of this imperative, as well as its seemingly facile capacity to appeal to audiences worldwide contributed to an atmosphere of resistance to the American film industry's increasing conglomeratisation.

The same year that Vinterberg completed *Festen*, von Trier created his Dogme 95 effort. Titled *The Idiots* (1998), the film is the second in what von Trier calls his 'Good Woman trilogy', which also includes *Breaking the Waves* (1996) and *Dancer in the Dark* (2000). All three of the Good Woman films centre on a woman who is driven by 'goodness' to make a series of choices that invariably end in tragedy. In this case, the central figure is a hapless participant in a troupe that decides to act mentally challenged in order to limn the boundaries of social propriety and emotional intensity; in the process, she finds herself confronting the effects of her activities on her family, with tragic results.

The film's utterly unpredictable path, as well as the often disturbing confrontations that occur onscreen, make the film riveting, if uncomfortable. Von Trier encouraged his cast members to explore emotional depths, which he helped provoke not only by having numerous nude scenes, but by directing without clothing himself. Several critics highlight the film as a breakthrough for von Trier, arguing that his earlier films, including *Zentropa* (1991), were almost clinical in their precision. Gradually, however, von Trier's work has shifted, allowing a degree of chaos that finds full expression in *The Idiots*. Beyond von Trier's own evolution as a director, however, the film is also an allegory for the relationship between the Dogme brothers and Hollywood, with the 'idiots' being those who eschew conventional filmmaking wisdom in order to achieve a connection with something presumed to be far more authentic.

While von Trier and partner Peter Aalbaek Jensen already owned a production company named Zentropa, in 1999, the director refashioned several abandoned army barracks in Avedøre, outside of Copenhagen, as a 'Danish Film Town', where he has made several subsequent features. Von Trier's next film, *Dancer in the Dark,* was not a Dogme production, but it employed miniDV – some scenes were shot with as many as 100 tiny video cameras – and von Trier often held the camera himself. Starring

Björk as Selma, a young mother and factory worker slowly going blind, and Catherine Deneuve as her friend, the film is a musical, with dance sequences interrupting the tragic tale. *Dogville* (2003) similarly incorporated numerous DV cameras to aid visualisation; the film was shot on a nearly bare set, with theatrical lighting and a bank of cameras suspended from above. Von Trier wove many of these overhead shots together digitally during post-production.

Subsequent Dogme films include Søren Kragh-Jacobsen's family melodrama *Mifune*, the third Dogme effort, which won the Silver Bear at the Berlin Film Festival in 1999; Kristian Levring's *The King is Alive* (2001), the fourth Dogme film, which he shot on the Namibian desert over six weeks; and Lone Scherfig's comic romance *Italian for Beginners* (2000).

While the Dogme 95 movement is Danish in origin, it has had a tremendous impact on filmmakers worldwide. American director Harmony Korine, whose films *Gummo* (1997) and *julien donkey-boy* (1999) are two of the most radical and original films of the last decade, was inspired by a similar Dogme desire to ground filmmaking in some essence of the authentic. *Gummo* is a freeflow narrative tracing the haphazard paths of several kids in Zenia, Ohio; the town had been devastated a few years earlier by a tornado, explains the voice-over, leaving a prevailing sense of isolation and decimation. *julien donkey-boy*, an 'official' Dogme film (the sixth in the series when the filmmakers were still counting), similarly eschews a traditional storyline, instead following the wayward exploits of the title character, a schizophrenic played by Ewen Bremner. The film was shot by Anthony Dod Mantle with the desire to achieve a look resembling photocopying. Both films follow von Trier's *The Idiots* in celebrating a degree of chaos during the production process and in fomenting a fundamentally inscrutable narrative trajectory while mining intensities of emotion onscreen; both films also provoked violent reactions among audiences and critics alike.

In part due to timing, but also to the calibre of projects presented under the Dogme umbrella, miniDV and the Dogme restrictions were indelibly connected. The format a decade later still inspires connotations of a gritty aesthetic and chaotic, often unpredictable narrative structure, despite the tremendous range of projects produced since *Festen*. But more than that, Dogme's advocacy for an international avant-garde combined with a democratised filmmaking practice has been yoked to the format,

in spite of the group's decidedly contradictory stance on the potential of such a practice. As Murray Smith points out, the movement was at once Romantic in its aspiration toward an evanescent authenticity while at the same time being deeply ironic. Writing about *The Idiots*, Smith notes that the film 'walks a fine line between cynicism and nostalgia', ridiculing the antics of the characters in the film while also refusing to 'give up entirely on the anti-bourgeois ideals, rhetoric and tactics of the avant-garde' (2003: 119). So too did the Dogme 95 filmmakers waver, hoping idealistically for some way to connect with the authentic in a world where such a thing no longer exists.

American digital

If the Dogme 95 movement and the release of *Festen* were key moments in the inauguration of the DV filmmaking movement and the attempt to rethink contemporary cinema, *The Blair Witch Project* (1999) presented a peculiarly American version of the movement's potential, thanks in no small part to the film's spectacular performance at the box office and the transformation of the film's $40,000 production cost to a $140 million gross. The film was preceded by Lance Weiler and Stefen Avalos' extremely low-budget effort *The Last Broadcast* (1998), a project that failed to ignite audiences the way *The Blair Witch Project* did, although it also illustrates a key point in the nascent filmmaking movement's genesis, namely that it was indeed possible to make a compelling feature film for far less than $100,000.

The Blair Witch Project wears its low budget on its sleeve, presenting itself as a documentary shot on Hi-8 and 16mm by three film students as they wander through the Black Hills Forest in search of the fabled 'Blair Witch'. Co-directors Daniel Myrick and Eduardo Sanchez guided the trio (Heather Donahue, Joshua Leonard and Michael Williams) using GPS technology and notes giving direction for each of the actors, who did not have a script, nor did they know what their colleagues would do at any given moment. The shoot took eight days, during which time the cast, cut off from their directors and the rest of the world, grew increasingly exhausted and manic.

Myrick and Sanchez built anticipation for the film through an online presence, teasing the film long before it was ready to arrive in movie

theatres. The film's success is often attributed in part to this maneuvre, and indeed, the Internet has since become an essential, if often misused, medium for exposing works-in-progress.

The success of *The Blair Witch Project* helped spark an avalanche of interest in digital filmmaking, and along with it, a renewed rhetoric of transformation, one which was fueled to a large degree by several production companies founded in the late 1990s or in 2000, all of them sharing the mandate to make inexpensive digital features, and to extend the independent film movement that had gained momentum in the early 1990s, but which by 1999 was losing steam. Invariably the founders of these companies, along with many filmmakers and pundits, insisted that DV was going to change filmmaking forever.

Indeed, 30 years earlier analogue video had also been touted as a means of dramatically cutting costs and democratising access to production in a manner that would revolutionise American media practices. As so many media historians have noted about earlier technologies, however, many bring with them euphoric predictions of vast change and the fulfillment of democracy, but little actual change ever occurs. Cultural critic Grant Kester highlights the repetition of these mythologies that greet each generation of technological innovation. Digital media, especially with respect to feature filmmaking, he notes, was no exception. The mechanical loom, the assembly line, electricity, the telephone – these all fit into the category of amazing and transformative technologies that were heralded as having the potential to mobilise democracy, equality and a better and easier life. Kester notes that our experience with these technologies is akin to what Leo Marx describes as the 'technological sublime': their dimensions or limitations are literally beyond our imagination.

This technological sublime became the rallying cry for a host of boutique production companies founded to promote digital production. New York-based producers Jason Kliot and Joanna Vicente, for example, founded Blow Up Pictures in 1999 as an outgrowth of their older company Open City, and planned to produce six low-budget features annually. They hoped to find projects that would be similar in their creative dissonance to Jim Jarmusch's *Stranger Than Paradise* (1984) or *Poison* (1991) by Todd Haynes. Their first digital effort was Miguel Arteta's feature *Chuck & Buck* (2000), a groundbreaking film in the sense that it eschewed the visual chaos of *The Blair Witch Project*, as well as the wholehearted grittiness of

the Dogme 95 films. The film was shot using two Sony VX 1000 cameras, but Arteta, who had been inspired by *Festen* and the image quality of the film's close-ups, did not want to replicate that film's often freefloating camera work and emotional turmoil; instead he hoped to create similarly appealing close-ups, which he felt would enhance his story's intimacy, and to be able to create an intense yet comfortable environment on-set. The film screened to much acclaim at the 2000 Sundance Film Festival, adding another possibility to the slowly burgeoning video vernacular.

While *Chuck & Buck* did much to legitimise miniDV, Blow Up also supported Dan Minahan and his film *Series 7* (2001), which touts the format's link to television in general, and to reality TV and surveillance video in particular. Designed structurally in a series of episodes, the film follows the exploits of a group of characters enmeshed in a surreal game in which they hunt down and kill each other, progressing from level to level with each murder. In this case, the film's look was designed to replicate the run-and-gun shooting style of a documentary film crew tracking the actions of the various contestants, while the interstitials were designed to match the graphics and cutting style of reality TV shows such as *Cops* and *Real Stories of the Highway Patrol*, helping complete the film's mimicry of television.

In addition to Blow Up, there were several other key production entities founded to promote DV filmmaking in the late 1990s. Director Gary Winick created Independent Digital Entertainment (InDigEnt) in 1999. He invited a series of writers, directors and actors to propose projects that would take advantage of miniDV's particular assets. InDigEnt's projects include Rebecca Miller's award-winning *Personal Velocity* (2002), a project interesting in its deviation from the traditional feature-film format. The film was shot by cinematographer Ellen Kuras, who had worked with Miller on her first feature, *Angela* (1995), which earned the Filmmakers' Trophy and Cinematography Award at Sundance in 1995. For *Personal Velocity*, Miller adapted three stories from her book collection of the same title. In the first, Kyra Sedgwick plays a mother with a rough and reckless past trying to disentangle herself and her three children from an abusive husband. Miller and Kuras decided to capture this brute force by shooting in a documentary style, using a handheld camera. The second story is about Greta (Parker Posey), an intellectual book editor living in New York. For this section, Miller and Kuras used a tripod and carefully choreographed movement within the frame, while for the third section, in which Fairuza

Balk plays Paula in a story of emotional turmoil and abrupt discovery, the filmmakers used macro lenses to give a sense of intimacy and myopia.

The film is perhaps most significant in that it won the Grand Jury Prize as well as the Cinematography Award at Sundance, which is quite a feat for a film shot on a pair of Sony PD150 miniDV cameras. But the film was also significant in being episodic; while Miller was initially inclined to tie the stories together, she ultimately decided against it, and the film was released as three separate, yet similar, short stories linked together by the title.

Other InDigEnt films include *Tadpole* (2002) starring Sigourney Weaver, which too gained a degree of notoriety in featuring an A-list actress in a small film shot on miniDV. While critics complained about the image quality, and there was talk about reshooting the entire film on celluloid, the project nevertheless was considered a success in demonstrating once again that the slick production values of Hollywood cinema are not central to a film's appeal. The company continued to prove its abilities with *Pieces of April* (2003), a touching family drama staring Katie Holmes and Patricia Clarkson that manages to tell the traditional holiday angst story inexpensively and with great heart.

Peter Broderick, a long-time advocate of low-budget independent filmmaking, headed Next Wave Films, which initiated 'Agenda 2000' in late 1999 as a means of funding digital production, while Greenestreet, Visionbox and Intertainer round out a slate of early DV promoters. Several have since folded, or slowed production dramatically, but their activities helped funnel financing toward the earliest DV features while also exploring disparate production, transfer and aesthetic options.

Filmmaker Rob Nilsson adds another element to the dense filmmaking terrain with his work among homeless residents in San Francisco's Tenderloin district. Nilsson, whose film *Signal 7* (1985) was shot on small format video and became the first feature film transferred from video to film, uses miniDV in ongoing workshops (called 9 @ Night) designed to encourage participants to tap into their own emotional and psychic worlds as a resource for narrative features. Striving to mobilise the intensity of everyday life in fictional form, Nilsson and an evolving team has written, directed and acted in several feature films; Nilsson travels internationally extolling his methods for combining low-tech filmmaking tools and emotional truth as the seeds of the strongest cinema practice.

Digital documentaries

While digital production tools certainly had a strong impact on narrative feature filmmaking, they also affected documentary production in a positive way, offering filmmakers a viable method for producing low-budget films. Bennett Miller's vibrant portrait of Timothy 'Speed' Levitch in *The Cruise* (1998) is often cited, along with *Festen*, as the film that brought DV international attention, inspiring hundreds of filmmakers to experiment with the format. Shot with a miniDV camera that dances around its subject with abandon, *The Cruise* is a not just a portrait of the inimitable tour guide, but also of a city, using grainy black-and-white images to capture the essential nature of New York.

More politically motivated documentaries, such as Judith Helfand's *Blue Vinyl* (2002), take advantage of the format's low cost to shoot extensive footage. In *Blue Vinyl*, Helfand spent a great deal of time building a case against the use of the potentially highly toxic PVC as a building material. Other filmmakers have mined DV for its expressive potential in first-person, essayistic projects, such as Agnes Varda's *The Gleaners and I* (2000), a film that ably illustrates the convergence of larger political issues – waste, poverty, hunger – with personal concerns, here conveyed in the very manner in which Varda holds the camera, turning it on herself to muse on the connotations of 'gleaning', and her own process as a film-maker-as-gleaner.

Digital documentaries raise issues regarding DV's essential difference from film. Whereas film stock registers an indexical connection to the world through the impact of light striking, and altering, emulsion, thereby forming a physical and ontological connection to the world, DV's transformation of light into digital information severs that connection. William J. Mitchell examines this evolution in his book *The Reconfigured Eye: Visual Truth in the Post-Photographic Era*, writing that for more than 150 years, traditional photographs

were comfortably regarded as causally generated truthful reports about things in the real world, unlike more traditionally crafted images, which were notoriously ambiguous and uncertain human constructions – realisations of ineffable representational intentions ... The visual discourses of recorded fact and imaginative

construction were conveniently segregated. But the emergence of digital imaging has irrevocably subverted these certainties, forcing us to adopt a far more wary and more vigilant interpretive stance – much as recent philosophy and literary theory have shaken our faith in the ultimate grounding of written texts on external reference, alerted us to the endless self-referentiality of symbolic constructions, and confronted us with the inherent instabilities and indeterminacies of verbal meanings. (1992: 225)

Digital documentaries often celebrate this confrontation overtly, acknowledging in explicit terms the presence of a particular point of view, as in the animated drawings that transform documentary footage in the short films of Tommy Pallotta and Bob Sabiston, or pointing to the partial worldview as in Varda's highly personal essay, inflected literally through her hands and skin.

Fictional films certainly play with DV's connection to home video and a documentary sensibility. In *Tape* (2001), for example, Richard Linklater shot in real time in a single hotel room producing a film that is theatrical in its unities of time and space but essentially cinematic with its dancing camera and infinite angles. Working from a one-act stageplay written by Stephen Belber, Linklater's main quandary was how to make a story set in a single, dingy motel room that occurs in real time work as a compelling, visually interesting film. The story is set in Lansing, Michigan, where Vince (Ethan Hawke), who divides his time between selling drugs and putting out fires, meets up with high-school buddy John (Robert Sean Leonard), a filmmaker screening his first film at a local festival; as they tease each other, catch up, and trade anecdotes about the past, the pair begin to dispute interpretations of a particular, volatile event in the past. They disagree on motives, propriety and violence, especially as it relates to sex, and they struggle over ideas about what it means to be a man. Things get more complex when Amy (Uma Thurman), who has been romantically involved with both men, arrives, helping reveal yet another set of angles on the past.

Linklater liked the challenge posed by the film's real-time structure, and even contemplated trying to shoot the film in a single take. Indeed, he had long wanted to make a film that is extremely well-rehearsed, with every detail so planned out that he could shoot it like a documentary. He

decided against this tack, noting that the film would then be basically about a director showing off. Instead, he went in the opposite direction, showing every action he possibly could, explaining that he wanted to create a filmmaking style akin to Cubist collage. Taking the single-room constriction and the fact that his audience would never be disoriented, Linklater began to wonder what would happen if he tossed aside shooting conventions, and cut the film according the emotional intensities as they evolved throughout the story. The effect is similar to a documentary in its temporal pace; however, the mobile camera treats the space from an overtly authorial stance, underscoring the piece's theatrical nature as well. While certainly not a documentary, the project is an exploration of the cinematic tropes that tend to delineate these forms.

Elastic reality

While the Dogme 95 films, low-budget narratives and documentary explorations offer compelling paths through the recent history of DV filmmaking, there are many others. Indeed, part of the ongoing creative impulse shared by filmmakers has been to find new ways to use digital tools. In his essay 'What is Digital Cinema?' Lev Manovich notes that digital filmmakers work with 'elastic reality' thanks to the ability to composite, animate and morph images. Using this elasticity to expand the spaces of cinema, both within the frame by crafting new story spaces, and outside the frame in terms of re-thinking the distribution and exhibition of films, adventurous filmmakers welcome their position at the intersection of diverse influences and artmaking practices. While it would be impossible to adequately characterise something as sprawling and diverse as 'digital moving image media', even within the confines of the feature-film format, there have nevertheless been three discernible trends in more experimental uses of DV in feature films.

First, there is the already mentioned hybridity of media, a cheerful mixing of film, video and photography, as well as an easy mixing of live action and animation. Indeed, experimental feature filmmaking is often not so much concerned with 'shooting' as with 'capturing'; it is less about creating pristine images of perfectly orchestrated and highly composed events and more about collecting a body of materials that will then be manipulated extensively, pixel by pixel if necessary.

Second, digital media production, even in the feature-film world, tends to be highly referential. Perhaps due to the fact that so much of the process involves collection and assembly, the resulting images are often collages of new and appropriated materials; there is a sense of entitlement toward images, as if, like words, borrowed images constitute the basic building blocks of a shared language.

And third, digital video has contributed to the possibility of pushing films outside of the boundaries of the cinema, onto the Internet and into gallery spaces where stories are repurposed as they are re-spatialised.

One example of this hybridity is evident in Richard Linklater's *Waking Life* (2001), a film made in collaboration with filmmakers Tommy Pallotta and Bob Sabiston. Pallotta and Sabiston are known for a series of short films in which they use proprietary software to draw over and animate footage shot on video; with *Waking Life* they shot an entire feature film, cut it together, and then engaged the assistance of thirty artists, each of whom chose a character or other element of the film, and animated it. The result is similar to some of the rotoscoped animations of the 1970s by Ralph Bakshi, but there is a playfulness and whimsy that comes from the artists' choices and keeps the film visually stimulating. Indeed, the beauty of this filmmaking style is in how it treats the 'real': rather than slavishly replicating reality, the artists make it abundantly clear that everything the viewer sees is filtered through a point of view.

Eric Rohmer similarly insists that we reckon with the constructed image. Perhaps best known for his work during the 1960s with the French New Wave, Rohmer achieves a unique hybrid form of image-making in his film *The Lady and the Duke* (2002). Set in the 1790s, the story traces the true-life exploits of Grace Elliott (Lucy Russell), who passionately defended a former lover during the French Revolution, gallantly risking her life in a world rife with torture, massacre and death by guillotine. What distinguishes the period piece is that Rohmer, disappointed with other period films set in Paris that are often shot in quaint towns nearby, decided that he wanted his audience to see the Seine – not just a river but the real Seine – and the actual streets that Elliott describes in her memoir. So he decided to insert his characters into painted backdrops in order to depict Paris during the Revolution as accurately as possible. Painter Jean-Baptist Marot spent two years creating 37 different backgrounds, which were then digitally layered with footage of the actors. The result looks less like video

FIGURE 3 Still from Tommy Pallotta's music video for Zero 7's *Destiny*

than a meticulously rendered kinetic painting, a costume drama that is at once real and strangely flat and static.

Both *Waking Life* and *The Lady and the Duke* were essentially created on the computer, which serves as the temporary staging area for the disparate image sources that are fed into it. The camera plays a role to be sure, but the film is substantially crafted in the process of bringing together and layering various elements into a single image. In both films there is little attempt to suggest a photographic representation of the world; instead, both present the world as an image construct, one that may at some point rely on photography, but in which the photographic image is essentially transformed.

Another form of hybridity is achieved in mixing film images with footage shot on digital video. Spike Lee's *Bamboozled* (2000) was shot using both Super 16 and miniDV, with the film footage designating material made for the television show within the narrative and the video imagery designating the real lives of his characters. Lee also incorporated archival footage from early narrative films, showcasing the racism in early depictions of blacks in Hollywood.

Steven Soderbergh similarly distinguished between different story worlds in *Full Frontal* (2002), touted as a sequel to *sex, lies and videotape* (1989), made on the heels of completing the big-budget *Ocean's Eleven* (2001). Soderbergh was ready to try a smaller, edgier project, and *Full Frontal* offered that option. The film was shot primarily on miniDV with a $2 million budget on an 18-day schedule, with his A-list cast agreeing to low-budget filmmaking constraints. Soderbergh handled the camera throughout the shoot, and then joined his editors in cutting the resulting 50+ hours of footage using Final Cut Pro 3; they generated a first cut within three weeks of the production's wrap. The film's story includes a film-within-a-film and uses miniDV and 35mm to designate the different story-worlds. Soderbergh highlights the differences between the two formats, explaining that he was interested in the aesthetic connotations of each. That said, Soderbergh wanted *Full Frontal* to have a very particular look, namely like colour Xerox, or like, in his words, footage processed in gasoline. Interestingly, in order to achieve this effect, Soderbergh turned not to digital image processing but to photochemical manipulation, working with a lab to invent a printing sequence that degraded the image to the extent that he desired.

Other filmmakers have mixed film and video as well, including Jean-Luc Godard who divided his film *Eloge de L'Amour* (*In Praise of Love*, 2001) into two halves, with the first half shot in black-and-white 16mm and the second half in lusciously colored DV footage. Nichola Bruce's *I Could Read the Sky* (1999) mixes 35mm and miniDV footage to distinguish between past and present. In all cases, regardless of narrative motivation, the shift signifies a willingness to abandon the seamlessness of traditional narrative in favour of calling attention to disparate registers of reality, memory or consciousness, here signified by the different media. What makes the shifts so interesting is that they call attention to the very fact that we are uncomfortably aware of the dispersion of these registers at all.

A desktop aesthetic

British filmmakers Peter Greenaway and Mike Figgis push the composited image world one step further in seminal digital projects that emphasise the role of the image frame, even referencing the frame as the site for the collision, layering, interpenetration and general orchestration of disparate

elements. The result is what might be dubbed a desktop aesthetic, as it cannot help but point to the visual syntax of the computer screen and its cacophony of frames and layers.

Greenaway has consistently pushed the boundaries of traditional narrative filmmaking across his 30-year filmmaking career with a body of work that includes more than 400 projects. He claims, however, to have been hindered by what he calls 'the four tyrannies', namely the tyranny of text, the actor, the camera and the frame. In regard to the tyranny of text, Greenaway insists that cinema has forever been influenced by, linked to, and outdone by the novel; in his own work, Greenaway subverts this tyranny by making text explicit, often incorporating images of writing as a layer across other images. Greenaway undoes the camera's tyranny by insisting that it is only ever a recording medium; he is not interested in the intricacies of cinematography. Similarly, he dismisses the tyranny of the actor, relegating his cast members to the status of objects that require manipulation in much the same way that other elements of production design require thoughtful placement and movement. Finally, Greenaway avoids the tyranny of the frame by breaking the rectangular frame of traditional cinema into numerous sub-frames, creating a form of subversion through multiplication and collision.

As a result of these four tyrannies, Greenaway constantly calls attention to the frame circumscribing his images, asking us to consider what we are watching and why. He also strives to synthesise the graphic world with the real world through the use of text. Recalling Laura Mulvey's dictum, he says he strives for a sense of 'passionate detachment', such that we are ever cognisant of the representational world as a highly fabricated construct.

While these strategies are evident in films such as *Prospero's Books* (1991) and *The Pillow Book* (1996), he recoils against the four tyrannies most adamantly in *The Tulse Luper Suitcases*, a massive project that includes three feature films (*The Moab Story, From Vaux to the Sea* and *From Sark to Finish*), a television series, 92 DVDs, a massive website and gallery exhibitions showing 92 suitcases. Greenaway extends the story of his character Tulse Luper across multiple media platforms, creating a narrative that has no discernible end but instead is a massive collection of sometimes conflicting data that refutes any sense of closure or the boundedness of any framing device.

Mike Figgis also bristles against the constraints of the rules of cinema with the goal of creating a 'virgin cinema', one that will allow viewers to experience their relationship with filmmaking in a fresh way. His first effort in this endeavor was *TimeCode 2000* (2000), a feature film shot with four cameras, all running concurrently and recording four convergent strands of a single story. The narrative follows the sometimes erotic, sometimes ridiculous antics of several characters who begin in disparate parts of the city and eventually collide in the offices of a small production company in Hollywood. While all of the actors knew the basic elements of the story outline, they were encouraged to improvise, and thus the 93-minute performance of the film was extremely theatrical. Figgis pushed his experiment further, however, in showing all four camera viewpoints onscreen simultaneously; the screen is divided into four quadrants, with varying sound levels helping guide viewer attention. Figgis has 'performed' the film several times, mixing the sound live in front of audiences, directing and redirecting the course of the narrative into strikingly different combinations.

In a project that continues the theatrical performance required for *TimeCode*, filmmaker Aleksandr Sokurov created *Russian Ark* (2002), a single-shot feature film made in conjunction with cinematographer Tilman Büttner, who specialises in Steadicam handling (he was responsible for the careening camera in *Run Lola Run*). The majestic and technically sophisticated film was shot in the famed Hermitage Museum in St. Petersburg in a single afternoon using the Sony HDW-F900 camera rigged with a special hard drive capable of storing 100 minutes of high definition images. Büttner and Sokurov covered more than 4,265 feet in the museum, shot more than 800 actors, passed by three live orchestras and chronicled 300 years of history in a single 87-minute take.

Both Greenaway and Figgis, in their overt multiplication of screens and layering, might be said to be working within the realm of what Marsha Kinder has dubbed database narrative:

> Database narrative refers to narratives whose structure exposes or thematises the dual processes of selection and combination that lie at the heart of all stories and that are crucial to language: the selection of particular data (characters, images, sounds, events) from a series of databases or paradigms, which are then combined to generate specific tales. (2002: 6)

Kinder continues, noting that these structures are evident in numerous art films, including *La Jêtée* (Chris Marker, 1962), *Last Year at Marienbad* (Alain Resnais, 1962) and *Celine and Julie Go Boating* (Jacques Rivette, 1974), for example: 'Such narratives reveal the arbitrariness of the particular choices made, and the possibility of making other combinations which would create alternative stories. By always suggesting virtuality and the wave of potentialities linked to the uncertainty principle, such narratives inevitably raise meta-narrative issues' (ibid.).

In their work, both Greenaway and Figgis offer their viewers a surplus of narrative information, underscoring the processes of selection and combination. Greenaway expands beyond the confines of the frame, crafting a project of immense proportions that can only even theoretically be completed by a viewer with the enormous patience to undertake such an endeavor. Figgis likewise revels in excess, showing viewers the footage that would normally be excised and allowing multiple paths through the narrative. While Kinder points to the lengthy history of films using a database structure, the form seems eminently suited to digital filmmaking and a digital aesthetic, in part due to the technology's fundamental ability to allow mutable processes of combination and selection. Indeed, this process might be regarded as central to any attempt to define a digital aesthetic.

A third aesthetic

In an interview in 2000, German filmmaker Caspar Stracke described his hybrid film *Circle's Short Circuit* (1998), a project composed of five separate sections designed to be screened in any order, as evidence of an evolving 'third aesthetic'. Stracke shot his film on 35mm and DV and then melded the two formats to create a project that is at once visually lush and clearly a digital creation. The project borrows the characteristics of telephone communication – static, interference, indeterminacy and flow – and the studies of media philosopher Avital Ronell to riff on the rhythms, noises and glitches that characterise contemporary communication and, by extension, how we understand the world. Each section employs a style referencing a particular cinematic era or genre, and the disparate storylines connect only in one scene. Otherwise, the film celebrates diffusion in a dense, fascinating assembly of voices, images and text. The story, in being neither fact nor fiction, is, like its aesthetic, a third thing, too; the pieces add up to a film

that exemplifies the confusion and excitement implicit not only in a new form of filmmaking, but in the collapse of metaphysical certitudes.

Neither film nor video, but instead a cinematic/DV hybrid that revels precisely in its impurity, this third aesthetic has no discernible origin and no teleological aspirations. Instead, like so many other things in contemporary culture, the style is cobbled together from bits and pieces, in this case, of film and tape, gathered here and there, with a disregard for 'proper' framing, camera movement and visual coherence. While the most recent generation of American avant-garde filmmakers based their work on a kind of oppositional refunctioning – the theft and recycling of images from contemporary culture, and an almost violent depletion and destruction of the beauty and glamour of the image – filmmakers working with miniDV often move in the opposite direction. There is still a strong tendency toward appropriation and collage, but guilt about the desire for beauty has given way to a celebratory effusiveness. Further, Stracke's third aesthetic helps embody the mixed forms evident in many projects that merge fact and fiction to create personal essays, film loops and avant-garde projects eschewing linear storylines.

On and off the Net

Narrative feature-film experimentation continues in other directions as well, in an ongoing expansion and collaboration with other media and artforms. One of the most interesting of these projects is also one of the oldest.

On 23 May 1993, writer/director David Blair 'screened' his experimental video *Wax, or the Discovery of Television Among the Bees* on the Internet. The piece, which began as a hypertext story, is described by Blair as an 'electronic cinema feature' and most of its 2,000 shots were either processed in post-production or synthesised using analogue and digital techniques. Blair wrote the script, which took over six years, in tandem with the project's 'image composition' such that the composing of the script on a word-processor and the composing of the images on a non-linear editing system merged, if not technically then certainly in his thinking. Blair's working method suggests what was at that point an emerging shift in potential ways to imagine story construction. (Blair claims that *Wax* was the first independent feature cut on a non-linear system.) Indeed,

he connects his work with what he calls a 'spatialised fiction', made of fragments that 'existed like connected places or many-exited plazas'. Using Storyspace, a program that facilitates the creation of hypertext fiction, Blair noted that he was able to see written fiction as spatial – in the program, his narrative was composed of linked text-boxes arranged in a deeply recursive web; travel through the fiction is akin to travel along a narrative topography.

While the feature-length video did not draw the mass audience of web surfers that traverse the Internet daily, the event nevertheless did garner considerable attention, with *The New York Times* likening the screening to Alexander Graham Bell's breakthrough moment with the telephone. Indeed, the event was revolutionary in suggesting the radical potential for expanded distribution/exhibition outlets. Blair showcased a subsequent version of the project at SIGGRAPH in 1994; the expanded video was a quadralingual hypertext version with several thousand hypertext links, thousands of stills and more than 500 digital segments that viewers could access via the Internet. Viewers were able to add text, audio and video to the original version; each viewer's version was also accessible. Overall, Blair's project introduced the notion of the 'processed' narrative – both the image *and* the narrative are processed via technology, a point that was very significant in Blair's creative process.

Canadian filmmaker R. Bruce Elder has also used the web in his feature film *Crack, Brutal Grief* (2001), a 130-minute project composed entirely of images pulled from the Internet. Elder treated the images, many of which come from sites mixing pornography and violence; his processing tends to augment the images' textures and colours, often making them into abstract, stylised and yet very tactile imagescapes. The project began when a friend killed himself and Elder wanted a way to deal with his grief and horror. He immersed himself in the web-based images, worked with them for hours at a time, studiously manipulating single frames in a process of grappling with the violence done to the human body. *Crack, Brutal Grief* is not a gentle film; instead it is an assault that somehow manages to give meaning back to images that have otherwise been emptied out. Further, Elder's experiment marks an interest in 'open source' filmmaking, whose mandate entails the free use and exchange of images.

There have been numerous other digital films, many significant in trying new techniques or using digital technology in innovative ways.

FIGURE 4 *Crack, Brutal Grief* (2001)

Indeed, while the industry at large works to make digital video indis-
tinguishable from film, the window of experimentation prior to a formal
entrenchment has offered many provocative directions. Wayne Wang's *The
Center of the World* (2001) linked the sexual implications of digital video to
a story about loneliness and desire, testing the boundaries of the MPAA's
ratings system while playing with the sense of voyeurism and intimacy of
the format. Shu Lea Cheang's exuberant, unabashedly pornographic *I.K.U.*
(2000) moved in a different direction, crafting a highly sexual sci-fi extrava-
ganza ostensibly continuing the story of *Blade Runner* ('iku' in Japanese
refers to orgasm). The story, like most porn narratives, moves from one
sexual act to the next with comic fervour, but Cheang keeps the activities
polymorphously perverse, cheerfully mixing males and females, gay and
straight with abandon. Drawing on an aesthetic derived from Japanese
manga, Cheang creates a visual spectacle quite unlike anything else. If
Hollywood was wary of the digital era, Cheang eroticises it, revealing an
erotic core at the intersection of technology, consumption and mobile,
digital, machinic sex.

Moving in a different direction, Zacharias Kunuk's *Atanarjuat: The Fast Runner* (2001) disobeyed the received wisdom regarding the limitations of DV cinematography, daring to shoot the sweeping white expanses of snow that form the story's backdrop while fighting against the difficulties of making cameras run in sub-zero temperatures. Based on an Inuit legend, the dazzling film is touted as the first Inuit cinematic endeavor, and is only one example among many of the ways in which DV is allowing new national cinemas to emerge and new aesthetic boundaries to be surpassed.

While the Hollywood film industry strives to meld film stock and digital video, the tools used in digital film and sound work have created an undeniable sense of creative convergence: because the tools for creating music, designing video games and doing graphic design overlap with those for making films, they have affected and influenced each other, and the impact is seen in many films created at the turn of the new century. For example the complex temporal structures of films such as Christopher Nolan's *Memento* (2000) and Tom Tykwer's *Run Lola Run* (1998) as well as Gaspar Noé's *Irreversible* (2002) derive from the repetitions and reversals common in video games. Similarly, music, especially electronic music, has had an impact on the pacing and atmospheric quality of several recent releases. In a film such as Lynne Ramsay's *Morvern Callar* (2002), storytelling is nearly suspended in favour of creating the character's sense of engulfment. We experience an ambient image, with the sound creating a distinctly corporeal set of perceptions that are tied to space.

In each of these instances, digital video has been instrumental in allowing some incursion into the Hollywood depiction of reality through illusion, shattering central myths concerning what audiences will and will not watch, both in terms of some notion of 'image quality', or in terms of narrative cohesiveness. They have also established a new vocabulary or syntax, one built on hybridity and mixed forms, melding disparate film stocks, genres and formats, and they have created a pathway for investigations of the real vis-à-vis its traumas.

2 BY DESIGN

In addition to altering the world of feature filmmaking, digital technology has also sparked new kinds of media art, much of it hybrid in form and situated at the intersection of disparate art-making practices, including graphic design, illustration, digital film, motion graphics, sound, animation and computer art. Software applications that simplify image and sound manipulation have made it much easier for artists to experiment, galvanising an international media community interested in crafting short, often music-driven motion pieces. Many derive from variations on broadcast design bumpers, show openers and various interstitials used for network branding, or increasingly creative feature-film title sequences. Others are music videos, but they bear little resemblance to the repetitive performance videos featured on MTV. And some are entirely abstract, recalling the live-action collages of *Ballet Mécanique* (Fernand Leger & Dudley Murphy, 1924) or *Anemic Cinema* (Marcel Duchamp, 1927), the abstract animations of artists such as Oskar Fischinger in the 1930s, or the evolution of the kinaesthetic cinema from the 1970s described in the introduction. Melding graphics, text, music and sound, and using the tools of advertising or broadcast design towards non-commercial ends, these projects are perhaps best described as 'design shorts'. Their position at the intersection of media art and commercial production is significant both for their impact on the aesthetic sensibilities of a wide range of commercial practices and as an innovative art form in their own right.

The evolution of the fields of motion graphics and broadcast design certainly influenced the emerging moving image vernacular. Broadcast

design refers to the moving images that introduce TV networks or dress up live-action commercials with animation and moving typography. These additions often remain essentially invisible to many contemporary viewers, just more visual detritus in an already cluttered media landscape. And yet the motion graphics field has certainly had its moments of high visibility. Starting in the 1950s, Saul Bass made film-title design an artform, mixing graphics and motion for the breathtaking sequences that grace *The Man With the Golden Arm* (Otto Preminger, 1955), the original *Cape Fear* (J. Lee Thompson, 1962), Hitchcock's *Vertigo* (1958) and many, many others. Pablo Ferro, another design icon, was responsible for the main titles of *Dr. Strangelove* (Stanley Kubrick, 1963), and went on to design the remarkable titles for *A Clockwork Orange* (Stanley Kubrick, 1971) and *Jesus Christ Superstar* (Norman Jewison, 1973), among others. Bass and Ferro did not simply make typography move; they made the entire screen come alive with a graphic sensibility that embodied the nascent artform's creative optimism and sophisticated edge.

In the 1980s, early computer technology helped catapult broadcast design into new dimensions, with the spinning logos for each TV network becoming ever more spectacular – giant, whirling dervishes of type in glistening steel, then neon, then glass, with the camera drawing viewers inside logos – and inside the screen. The high-tech corporate bombast got old quickly, but for a moment, the fluidity and effortless flights into screen-space seemed exhilarating.

In the 1990s, designer David Carson's grungy look and irreverent disdain for text – it does not always have to be readable, he argued – rocked the graphics world when it appeared, first in the magazine *Beach Culture* and then in *Raygun*. A little while later, the jagged, frenetic titles by Kyle Cooper for *Se7en* (1995) raised the bar again, rivaling the film itself with dark, haunting shards of images and words. More recently, the evocative design for the main titles introducing the HBO series *Six Feet Under*, created by Digital Kitchen, resonate strongly, carrying viewers from the credits into the story, not just through typography but through style and metaphor, too.

An older generation of design firms had already reinvented moving image design – R/GA was founded in 1977 and was home to some of the best current designers, many of whom have since opened their own shops. Pittard Sullivan was founded almost a decade later, and became,

in comparison with the abundance of boutique houses, a powerful behemoth. And Imaginary Forces, while still young as a company, is a potent trendsetter, with offices in New York and Hollywood, and an array of award-winning film title sequences to its credit, including those for *Spider-Man* (Sam Raimi, 2002) and *The Cat in the Hat* (Bo Welch, 2003). Each of these companies helped rethink the potential of moving image design while conjuring inventive approaches to marketing and branding. As creative as these companies are, however, they now represent the grand old school next to a spate of youthful and impertinent newcomers.

Critics generally cite the arrival of MTV in 1981 as the impetus for radical shifts in the world of broadcast design. 'Before the advent of cable television in the 1980s, on-air graphics of the Big Three networks had grown cold, corporate and unimaginative', writes Steve Curran in the opening to *Motion Graphics: Graphic Design for Broadcast and Film*. 'Flying metallic logos and staid solutions defined on-air graphics; they were products of technology and corporate culture more than of creativity and talent ... Then MTV arrived' (2001: 5). With its irreverent disdain for consistency and the sober, glossy branding of the networks, MTV inaugurated an era of creativity in the typically stolid broadcast realm, challenging competitors to match its wit, vitality and mutability. Not only did MTV showcase a burgeoning world of music videos, charting the rising creative trajectories of seminal directors and bands, but the channel also hired innumerable artists to help create interstitial material; many animators in the 1980s helped sustain challenging careers through work done for MTV. Further, as the channel grew older, it became more and more a testing ground for young talent, and many contemporary directors experimented with stylistic and even storytelling ideas using the music video, which could only exist as a viable form with the outlet provided in large part by MTV.

MTV is also frequently heralded as the source of the music video. However, as Neil Feineman and Steve Reiss point out in their book *Thirty Frames Per Second: The Visionary Art of the Music Video*, there exists an extensive history of music-related short films that reaches back long before 1981 and the advent of MTV, from the short musical films produced by the Hollywood studios featuring singers such as Billie Holliday and Cab Calloway, to the post-World War II video jukebox called the Panarom Sound. 'Music video', according to Feineman and Reiss, 'is just the latest in the music biz's parade of visual aids' (2000: 11).[1]

A few of the newer designers are artists such as Mike Mills and Geoff McFetridge whose hand-drawn illustration style belies the digital foundation that makes their images move so smoothly. Mills has made short films, music videos and commercials; he has designed logos; he has drawn album covers for the band Air; in 2004, he completed his first feature film, *Thumbsucker*; and he is also the co-founder, with Roman Coppola, of the Director's Bureau in Hollywood, which represents a handful of directors with similarly eclectic backgrounds and do-it-all career goals. McFetridge's best-known work may be the hand-drawn titles for Sofia Coppola's *The Virgin Suicides* (1999), which evoke a high-schooler's labored Pee-Chee folder scrawls, but his strong graphic style has added an edge to companies such as Burton Snowboards, whose kinetically branded graphic identity is enticing even to the most acrophobic snow-hater. Mills and McFetridge are the new millennium's rock stars, at least to a particular cognoscenti.

The arrival of the Macintosh computer played the most influential role in the evolution of moving image artforms, not only in filmmaking, but in the formerly distinct worlds of graphic and broadcast design. As in the filmmaking world, the computer offered a staging area in which designers could bring different ideas together, adding motion to traditionally static forms, whether it was text or images, and altering aesthetic trends dramatically, which in turn changed forms of communication. 'When the Macintosh

FIGURE 5 From *The Virgin Suicides* (1999) title sequence by Geoff McFetridge

computer was introduced to the field in the 1980s, designers began to layer and dissolve type and imagery – a practice that shattered the conception of a detached, objective reader', explains Stephanie Zelman (2000: 54). 'Designers began to endorse the sort of communication that would "promote multiple rather than fixed readings" and "provoke the reader into becoming an active participant in the construction of the message"' (ibid., citing Rick Poyner). For Zelman, this movement is epitomised by the graphic havoc of Carson's work on *Raygun*. However, the transition from transparent typography, when printed words dutifully convey meaning, to typography-as-image carries over into the world of moving images. This is true not only in broadcast design, where a network's identity is often presented typographically, but in short films and music videos, which often employ moving text as images to be looked at rather than simple conveyors of ostensibly 'objective' meanings.

The collision of text, graphics, moving images and music is also the collision of disparate disciplines, which find their meeting point in the computer. By extension, many of practitioners in this far-ranging field are not traditional video or film directors; instead, they are cross-disciplinary artists, working across an expanding field. Some work alone, while others collaborate in teams or as collectives, dividing duties according to skill sets. Some of the most interesting work is made as the 'extra' projects created after hours at broadcast design firms dedicated to creating moving imagery for commercial purposes. Companies such as Logan, Honest, Brand New School, Trollbäck, H5, Motion Theory, Stiletto, Happypets, Shynola and panOptic are just a few of the international groups intent on challenging the boundaries of the moving image artform.

This chapter traces contemporary music videos and design shorts, charting a series of tendencies and their implications, especially as they relate to reconfigured notions of space.

Spacing out

Thanks in no small part to their imbrication with the music industry, music videos are routinely dismissed as commercial tools, or when analysed, as in Andrew Darley's book *Visual Digital Culture,* they are dubbed 'decorative' and derided for their lack of depth and complexity. Music video directors are also routinely demonised as thieves, chastised for raiding

the archives of the avant-garde, stealing assorted techniques and even entire shots, scenes and scenarios. Those tactics most frequently borrowed include:

- the collage style of imagery found in the work of Bruce Conner, especially his groundbreaking 12-minute short *A Movie* (1958) with its dense collection of found footage imagery;
- the surreal, dreamlike or nonlinear narratives characterised by the work of Maya Deren and early Luis Buñuel, with the juxtaposition of shots to create absurd meanings, or the use of images that seem to have been culled from a dreamscape;
- image processing in which photographed images are treated to alter colour, density or clarity;
- jump cuts and rapid cutting, or, in contrast, slow motion imagery;
- scratching the footage, as in the work of Stan Brakhage or Len Lye.

While appropriation and sampling are the central tactics of a larger postmodern art practice, music video directors are still castigated for being thieves.

Despite the general dismissal of these works, many music videos, as well as design shorts, offer a compelling examination of some of the central issues that we face as a culture, and indeed, one might argue that these rather disparate artworks offer a map of contemporary anxieties, fascinations and concerns. Several tropes recur:

- the desire to represent the unrepresentable and to show places, such as memory or cyberspace, which cannot literally be depicted;
- the desire to re-purpose the tools of surveillance and control, underscoring the presence of cameras and other technologies of official scrutiny;
- the propensity for grids, layering and collage, often sparked by attempts to visualise chaotic sound;
- and finally, frequent geographical mappings, charting space via flythroughs.

Each of these tropes is emblematic of a larger desire and ongoing concern with the re-articulation of the notion of space, a project rooted in the

early 1970s and a moment that witnessed not only the introduction of the Internet, but the arrival of two key texts that are indicative of the shift to the assertion of space – rather than time – as the central issue for our era.

The first text is Henri Lefebvre's book, *The Production of Space*, a groundbreaking analysis that has recently become a central reference point in describing digital space. Lefebvre, who was influenced in part by Gaston Bachelard's 1958 text *The Poetics of Space*, dedicated his critical work to insisting that space is never a transparent, passive, neutral or empty backdrop; it is not an abstract or empty stage within which reality unfolds. Instead, according to Lefebvre, space is actively produced. Inspired by Marx's dictum that we make our own history, Lefebvre argues that we make our own geography, though we may never do it exactly as we please. Geography, like history, is always constructed within a set of lived circumstances.

Lefebvre thus challenges the ideals presented almost 250 years before by Immanuel Kant, who claimed that we enter the world with an understanding of time and space that comes prior to experience. Kant said that we could not understand anything if we did not have, *a priori*, a sense of time and space. Lefebvre instead argues that spatiality is a construction that socialises both physical and psychological spaces. Space is also always double, coming before and through social action; it is its foundation and embodiment.

A helpful analogy in imagining how space is produced in Lefebvre's terms is to consider the sense of space created in classical Hollywood filmmaking. When we view a typical film, the realist codes of *mise-en-scène* and continuity editing combine to create apparently seamless, totally coherent spaces. Yet we know that those spaces are radically disjunctive and wholly constructed. Similarly, according to Lefebvre, we accede to a spatial world that accords with the codes that are produced by a culture at any given time.

Another helpful perspective comes from Jonathan Crary, who, in his book *Techniques of the Observer*, makes a distinction between spectators and observers, noting that the Latin root for 'spectator' means to look at, whereas the root for 'observe' means to comply with, as in to observe a set of rules: 'An observer is ... one who sees within a prescribed set of possibilities, one who is embedded in a system of conventions and limitations' (1992: 6). In a sense, then, the space that Lefebvre was describing

is a space that is viewed by observers; a space that is always positioned within a system of conventions that limit the possibilities through which it may be seen as a space.

The second key text is Ernie Gehr's *Serene Velocity*, a 23-minute silent film, which is exemplary of the Euro-American Structural film movement that flourished briefly at the end of the 1960s and early 1970s. To make his movie, Gehr set up a 16mm movie camera in an empty industrial hallway. Then, shooting single frames, he adjusted the focal length of the camera lens four increments in each direction while exposing a pre-determined number of frames for each new focal length. The result is a portrait of the hallway that shifts back and forth erratically, moving ever closer and farther away to a pair of doors at the far end.

As a Structural film, *Serene Velocity* is fundamentally concerned with the specific materiality of cinema; in this case, Gehr illustrates the central role played by the lens, a role often made invisible in filmmaking. Indeed, as Scott MacDonald points out, the English word 'camera' is Latin for 'room' (1993: 37). However, in traversing the length of the hallway in a rapid back-and-forth movement, the film is also ultimately about space and its production through our cognitive apparatuses of perception and consciousness. The hallway is thus not a passive space that we enter. Instead, we produce the space in our minds by viewing and making sense of a series of film frames. As if responding to Lefebvre's book with a helpful illustration, Gehr has created a suitable complement to Lefebvre's ideas.

Further, *Serene Velocity*'s almost abstract set of constantly shifting patterns, alongside the alternating sense of penetrating the centre of the screen, and leaning back as the centre of the screen pulses ever outward, are precursors to the psychedelic visuals that Gene Youngblood described as 'synaesthetic cinema'.

Taken together – and combined with the fact that the networked information system that would become the Internet first went online shortly before the new year in 1970 – these texts suggest three points pertinent to digital filmmaking in general and design shorts in particular. First, they assert the primacy of space as our era's primary focus of concern. Over the ensuing 33 years, we have witnessed a radical reorientation of spatial perception, thanks in no small part to the inauguration of the Internet as a space that is, in a sense, not a space. This is certainly not the first time that this sort of disruption has taken place. Indeed, in many ways, the

shifts witnessed at the end of the millennium run parallel with those that accompanied the technological and social shifts in the nineteenth century. Throughout the 1800s, popular culture responded to new modes of travel, communication and industry with forms of entertainment that, as Scott Bukatman points out in his book *Matters of Gravity*, played with perspective, overwhelming scale and mimetic depictions of the natural world (2003: 80). Rhetorical figures of the sublime were invoked, with the sublime here being that 'which alludes to the limits of human definition and comprehension' (2003: 82). According to Jonathan Crary, the kineticism that emerged in the nineteenth century was based on the fact that 'visual experience was given an unprecedented mobility [and] was abstracted from any founding site or referent' (quoted in Bukatman 2003: 85). Bukatman adds: 'The sense of displacement or disorientation produced by the environment of the industrial city gave rise to new entertainments that produced cognitive and corporeal mappings of the subject into a previously overwhelming and intolerable space' (2003: 88).

In some ways, new forms of entertainment created a nexus for thinking about being in the world as that world and our experience of it is ever changing. Early forms of special effects, adds Bukatman, 'redirected spectators to the visual conditions of the cinema and thus bring the principles of perception to the foreground of consciousness' (2003: 90). As the US began to make the transition to being an information and technology-centred culture, the resulting anxieties became evident. Indeed, many contemporary films and videos stage the collision of the analogue and the digital. Further, media artists working today are supremely aware of the ways in which we have shifted from a culture of representation to one of data processing. As data plays an increasingly central role in our daily lives – from the technologies used by the military to banking systems – a new aesthetics has evolved, one that is about processing, networks and the use and constant re-use of images culled from an immense cultural database. This in turn creates a new role for vision and for space.

Second, these texts begin to expand the context within which we might talk about contemporary media practices. While the history of avant-garde film and the history of video art tend dutifully to be kept separate, with their respective sets of concerns, modes of production and exhibition spaces, the much touted convergence of contemporary media practices creates not only a rich cross-pollination among different fields, but a fascinating

dialogue between contemporary video and the history of avant-garde film. Indeed, many current media art projects return almost obsessively to the avant-garde's central tropes and concerns. Likewise, many of the projects instituted by practitioners of avant-garde filmmaking might find that DV offers the tools to accomplish many of the formal and conceptual projects that in traditional filmmaking were painstaking at best. Thus a film like *Serene Velocity* forms the impetus for a database narrative software appli-cation created by artist Barbara Lattanzi, while the kaleidoscopic vision touted by *Expanded Cinema* returns in a host of videos similarly mapping a world in fictive depth, with all the delirium, immersion and kinesis that marked the most spectacular visions of Gene Youngblood's era.

And third, these works evince a desire to penetrate, to map, and to chart. In a sense, they suggest a new form of cognitive mapping aligned with the desire for coherent navigation schemes and the possibility of logi-cal traversals through otherwise confounding spaces. These issues form a central trope in numerous works, speaking to the apparent desire to depict and comprehend the utopian possibilities of electronically constructed space.

Kaleidoscopic vision

While the array of music videos and design films produced since 2000 is vast, there are several notable trends. Many writers have highlighted the visual excess of much contemporary media, for example. In addition to Bukatman's description of 'topsy-turveydom' and kaleidoscopic percep-tion (2003: 119), Vivian Sobchack describes a giddy sense of freedom enabled by digital imagery:

> Electronic space constructs objective and superficial equivalents to depth, texture and invested bodily movement ... [C]onstant action and 'busyness' replace the gravity which grounds and orients the movement of the lived-body with a purely spectacular, kinetically exciting, and often dizzying, sense of bodily freedom (and freedom from the body). (1990: 57–8)

Angela Ndalianis uses the term 'neo-Baroque' to reference media projects that expand beyond the confines of the frame. She writes: 'Closed forms

FIGURE 6 *Gun Play* (2001) by Rico Gatson

are replaced by open structures that favour a dynamic and expanding polycentrism' (2004: 25). While she is discussing tendencies in serial narrative, the cross-platform migration of stories (from book to movie theatre to theme park, for example), and the excessive illusions of theme park attractions and special effects films, her attention to the impetus to break the frame works on a smaller level, too, to describe a body of recent music videos that depict that explosion within and beyond the frame.

Brooklyn-based artist Rico Gatson creates a dazzling – and neo-Baroque – explosion of kaleidoscopic imagery in his short videos *Gun Play* (2001), which pits Pam Grier in *Foxy Brown* against the cowboys in *The Good, the Bad and the Ugly*, and *Jungle, Jungle* (2001), which repurposes footage from *King Kong*. Gatson, who studied sculpture and video at the Yale School of Art, used a mirror filter to create the kaleidoscopic effect in both pieces such that the frame is divided into refracted quarters; the result is a series of symmetrical patterns entirely baroque in their excess and which help augment the sense of visual and aural chaos in the original footage. In *Gun Play*, a brazen Grier squares off against a series of steely-eyed gunslingers in a collision of genres, heroes and skin colours. Gatson plays with the sensory excess in both original films, but more importantly,

he captures the exclusiveness of the generic codes through outrageous juxtaposition. In *Jungle, Jungle* the mirror effect creates a pulsating allegory pointing to the threat of the Other, here figured as the many dark-skinned characters surrounding the hapless Fay Wray.

Gatson's short collision of texts offers an astute example not only of a kaleidoscopic aesthetic, but also of the rampant desire to use existing imagery as the material for subsequent projects. The questions underlying the impetus to appropriate have everything to do with power, and to the shifting role of the spectator, from passive viewer to active consumer, one who can transform cultural material through tactics of re-use and refunctioning.

While the volatile juxtaposition of Gatson's shattered images serve a political function, a great deal of the kaleidoscopic imagery in music videos and shorts operates as spectacle, providing a dazzling visual treat. Jonas Odell, of Stockholm's Filmtecknarna, used kaleidoscopic imagery in his video for Goldfrapp's 'Strict Machine' (2003), featuring Alison Goldfrapp performing the song in a dense graphic environment melding dogs, bodies and other whimsical entities, while the British collective Shynola crafted a lurid, nearly psychedelic video for 'Go With the Flow' (2003) by Queens of the Stone Age, featuring a climactic explosion of sex and destruction that can only be described as ecstatic. Alex & Martin also use a band – the White Stripes – as the centre for their kaleidoscopic endeavor for the 'Seven Nation Army' video (2003), with a triangular red and black image forming the centre for a dizzying series of shots moving ever forward through layers upon layers. In all three videos, the performances of the musicians become the foundation for the graphic unfolding of mirrored images, with a resulting experience of visual excess and kaleidoscopic movement that is as much about the exhilaration of new image-making tools as it is a reflection of the anxieties expressed by Bukatman.

Hybrid spaces

A recurring trope in many recent music videos and design shorts focuses on the construction of hybrid spaces that meld the so-called real with the patently fake. To some extent, these hybrid spaces reflect the ways in which the 'mediated' world aligns with the 'immediate' world, and the sense that our experience of the two is increasingly difficult to separate.

While theorists such as Jean Baudrillard view this intersection with grave skepticism, the projects themselves evince a sense of excitement, even exhilaration. In a sense, images of digital space serve as screens for the digital 'world'. What we are seeing is the analogue reference for a series of ones and zeros. The images that are created out of that conglomeration of code are not real and by extension, as Lefebvre might argue, the spaces that we inhabit are similarly produced through a series of codes that create a functionality that accords with what we need at a particular cultural moment. These hybrid spaces further insist that we confront the contradictions of space. The spaces that we view here are simultaneously flat and deep, unitary and dispersed, near and remote, real and fake, miniature and gigantic, live and recorded, reflective and immersive, and so on.

Perhaps one of the most compelling depictions of this spatial hybridity occurs in Michel Gondry's video for 'Star Guitar' (2002) by the Chemical Brothers, in which the world passing by as seen from a moving train shifts to accommodate our experience of it. In other words, a landscape dotted with trees, walls, telephone poles and bridges seems to be linked directly to the beats and sounds in the music; trees appear and then reappear in a subtle iteration of the music, the landscape embodying the sound. While the landscape appears to be 'real', there is no way that it could 'naturally' appear in synchronisation with the music the way it does, and seeing the transformation produces a sense of awe – the real become virtual. The video makes a direct reference to the plethora of films made at the turn of the last century which were shot from moving trains that exhibited an unbridled fascination with motion, and the traversal of space. Here, however, the emphasis shifts to a world ready to morph in response to our experience of it.

The inventive work of Gondry, as well as Spike Jonze, Chris Cunningham, Jonathan Glazer and Mike Mills, over the last decade has done much to invigorate the music video realm. Beginning in 1986, Gondry has created a body of work that is often technically quite simple, yet results in videos of stunning complexity. He has explained that his working method is to take an idea and keep pushing it to an extreme, a motto that he has used in conjunction with Lego building blocks, for example, to make a video for 'Fell in Love With a Girl' by the White Stripes in 2002, in which the simple animation of different-coloured Lego blocks depicts the two band members as they perform the song. The video for the White Stripes' 'The

Hardest Button to Button' is again simple pixellation, taken to an absurd degree, with the two band members moving beat by beat through an outdoor space. For 'Star Guitar', Gondry worked with his brother, Olivier 'Twist' Gondry, shooting footage of the landscape from the train multiple times to glean different qualities of light. The footage was then layered and altered to create the flurry of objects that appear and repeat in conjunction with the differing sounds in the track to become a literalisation of the landscape.

Numerous other short films and videos similarly focus on the landscape, or the cityscape, and its changeability. In Chih Cheng Peng's short film titled *Whizeewhig* (2002), the sense of uncanniness continues as images of buildings in San Francisco flex and turn in impossible mutation. The urban space refuses the stability that would allow us to map it, demanding instead a different set of tools for representation.

The work of British filmmaker Tim Hope often mines a similar hybrid territory. In the music video 'My Culture' (2002) and the short film *Jubilee Line* (2000), Hope combines live-action footage of people with constructed spaces. In *Jubilee Line*, for example, passengers, represented by actors, ride on a train rendered as a drawing. The figures, however, while 'live' also appear to be flat, in contrast to the urban environment, which appears to have three-dimensional depth. Hope plays with our expectations, showing in a very low-tech manner how graphic representations can easily be

FIGURE 7 Robert Bradbrook's *Home Road Movies* (2001)

combined with live-action footage to create deliberately unreal yet com-
pelling spaces. Similarly, Robert Bradbrook's stunning short *Home Road
Movies* (2001) mixes live-action and 3-D computer space to create a look
that resembles hand-tinted photographs to tell the story of a family and its
relationship to its car.

More significantly, however, these live-action/graphic hybrids point to
cultural anxieties about who and where we are in an increasingly mediated
world. They point to the potential seamlessness of real and fake worlds
and, by emphasising their constructedness, spark a sense of wonder, but
also of empowerment, allowing us to consider representations of space
and time that refuse the sense of dissolution caused by giant networks
of control; they also offer methods for constructing our own ensembles of
space and time.

Diagrams and flat spaces

A third category of short design videos is the entirely graphic or dia-
grammed animated project. Positioned in the very narrow gap between art
and commerce, these projects enact a form of reduction, using the inter-
national language of logos and graphics to illustrate visually rather than to
tell verbally. Johnny Hardstaff's *The History of Gaming* (2000), for example,
is composed of a long, horizontal parade of icons charting the evolution of
gaming from the 1970s forward. Set to a Minnie Riperton song, the piece
animates the icons, creating a visual timeline not just of gaming, but of its
visual iconography. Hardstaff, who studied graphic design in London at
St. Martin's, originally created the piece for himself. However, it was even-
tually purchased by Sony PlayStation, and Sony's PS logo was appended
at the timeline's conclusion, marking not only the platform's participation
within a larger cultural history, but blurring the very evanescent boundary
between art and commercials. The hazy delineation characterises much
of this work, as companies such as Nike offer funds to artists to create
moving image work based on their products.

The work of the French collective H5, founded in 1996 by Ludovic
Houplain and Antoine Bardou-Jacquet, has also been central to the
evolution of the graphics-driven video form. With the addition of Herve
De Crecy, Rachel Cazadamont, François Allaux and Fleur Fortuné, the
company expanded in number and creative form, from creating logos,

corporate identities and other marketing tools for a long list of clients into music videos, making their first video for 'The Child' (1999), a track by Alex Gopher. The innovative video takes viewers on a rollercoaster ride through the busy streets of Manhattan, rendered here entirely as text; the video becomes an amusing instance of concrete poetry, brought to fluid motion. Very similar in its text-based graphic representation to Jeffrey Shaw's 1988 interactive project titled *The Legible City*, in which participants pedal a stationary bicycle that seems to navigate through the graphical depiction of a city created out of text, the video nevertheless pushed text and typography to the fore as yet another tool in the expanding visual repertoire of music video directors. Bardou-Jacquet left the company in 2002, but H5 has continued to create inventive videos, including the 2002 video for 'Remind Me' by Royksopp, in which a young woman's entire day is mapped graphically, detailing the architectural construction of her home, mapping her route via transportation systems to work, and the path of her food, from farm to restaurant to digestion. The video maps the intersection of an astonishing array of systems, pointing to the centrality of data and our existence in an information-saturated world.

Graphic depictions of data form the centre for several projects by British filmmaker Richard Fenwick, who has contributed to this realm with an array of music videos and design pieces. Fenwick trained as a graphic designer, and co-founded his first company, OS2, in 1998 with Adam Jenns. His goal since then has been to merge graphic design, traditional filmmaking and a form he dubs 'graphical filmmaking' into a seamless mix. His first project along these lines was *States* (1998), made in collaboration with Jenns, followed soon thereafter by *People* (1999), a piece that combines live-action imagery with text and graphics. Fenwick shot documentary footage of people on bus and train platforms, hurrying from place to place in an urban environment, with a muted palette and grainy images so that the material resembles imagery shot by a surveillance camera. Fenwick then added an outline of a square to some of the footage as if to target specific individuals; scrolling numbers contribute to the sense that someone is tracking people, counting, watching and covertly controlling those being watched. Fenwick frequently divides the screen into moving grid patterns, creating smaller frames within the larger frame, and he also introduces text, first to name the possible occupations of those onscreen, and then to make statements that prompt viewers to interpret the footage in different ways:

'The average person is caught on camera at least 10 times a day', states one fragment of text, highlighting the piece's central theme.

Like many projects produced in this category, *People* is adamantly self-conscious, insisting on an awareness of what it means to be behind the lens of a panoptic technology. Further, Fenwick underscores the ways in which seemingly innocuous or neutral material is immediately shifted via the impulses of those interpreting the footage. In *Artificial Worlds* (2000), the sounds of dogs, birds, wind and water initially seem to correspond to the landscapes seen onscreen; however, at a certain point the image seems to devolve, breaking apart to reveal the signal that underpins it. The landscape becomes fake, a series of pixels and outlines charting the previously depicted landscape. The space resembles a graphic space, more akin to a video game than any habitable environment. The short, subtle piece deftly skewers presumptions of realism, using metaphors of surface and depth, but in the end revealing the superficiality even of the substructure.

In 2000, Fenwick disbanded OS2 and founded Ref:Pnt, an experimental research studio in which the director creates short work outside the demands of commercial endeavors. One of Fenwick's most significant projects under this rubric is *RND#*, a series of what will eventually be 100 short films investigating the impact of evolving communications technologies on people. In *RND#06: Underworld* (2000), Fenwick shows a placid San Francisco community, using slow pans of apartment buildings dotting hillsides in what is dubbed the 'Idyllic Mode'. When the video abruptly shifts to 'Com Mode', the audio track becomes a cacophony of noises made by dial-up modems and voices on cell phones, while the landscape images are overlaid with a dense web of graphic depictions of lines of communication, giving form to the 'noise' that moves invisibly through our world at any given moment. In *RND#91: 51st State* Fenwick pairs dark images showing flashes of light and outline diagrams with a voice-over conversation between a young man inquiring about the parameters of the Internet with various representatives of Internet service providers. His naïve inquiries about purchasing a piece of the Internet as one would buy a piece of real estate prove to be more complex than they appear. Like children's questions, they ask what seems to be obvious, but are actually questions that even 'professionals' have trouble answering. Again, Fenwick creates a succinct, graphically augmented motion piece that melds disparate image sources, resulting in a strong statement about the social implications of

technology. While many graphic or design films merely layer images and text with little thought about the ways in which form and content might illuminate each other, Fenwick's work, with its thoughtful attention to finding new ways to convey meaning, embodies the best of this hybrid form.

Animation nation

Moving even further away from the realism of live-action footage, entirely animated shorts and music videos offer yet another category of new digital media. Many are made with Macromedia Flash, first introduced in 1996, and are designed for delivery primarily over the Internet rather than on movie screens. Easily playable on a web browser, the relatively small file sizes and short download times quickly made Flash an industry standard for Internet animation. Even more remarkable is the program's use of scalable vector graphics, which could be shown large or small with no loss of image quality, offering filmmakers a very large potential audience both online and in movie theatres. As a result, many artists who had never worked in animation began to experiment with the software, and for a brief, intense period of two or three years, there was tremendous interest in the use of Flash as a tool for independent artists interested in creating work outside the standards and dictates of television and studio-based filmmaking.

New York-based multimedia designer Marina Zurkow is among those artists. In 1995, she joined SonicNet as founding design director, helping make the site one of the most celebrated multimedia works of its time. Working as a graphic and interface designer, she eventually moved into Flash-based animation, creating the bizarrely brilliant episodic web-based series *Braingirl*, featuring a naked female character with a large, exposed brain. In a series of nine episodes, the character has various adventures. Aside from its loopy central character, part of what makes the series extraordinary is its dismissal of traditional gender boundaries and its exploration of unusual events, helping depict a moment of cultural transition.

Numerous companies turned their attention to Flash-based work between 1999 and 2002 – Urban Entertainment's blaxploitation-inflected animation hit *Undercover Brother* eventually became a live-action feature film, while *Mr. Wong*, created by Pam Brady and Kyle McCulloch for the website Icebox beginning in 2000, became the focus of outrage, with viewers complaining about the show's racial stereotypes. Companies such as

RSUB (original home to *Braingirl*), AntEye, Heavy, Mondo Media and Wild Brain are just a few of the numerous companies that were part of the larger dotcom boom – and bust – that focused on offering new and aggregated media, and were, if momentarily, a boon to digital animation.

Perhaps one of the most interesting fall-outs of the brief window of enthusiasm was the arrangement made between Shockwave.com and filmmakers Tim Burton, who created the animated *Stainboy* (2000), and David Lynch, whose first animation series was *Dumbland* (2000). For his animation, Burton used material from his book *The Melancholy Death of Oyster Boy and Other Stories*, while Lynch turned to his own unconscious to create a world of violence and mayhem featuring gruff, foul-mouthed characters able to say and do things not permissible in the real world. But Shockwave and Flash have been put to innumerable uses since then. These range from work by *Futurefarmers*, which was founded in San Francisco in 1995 by Amy Franceschini as a design studio open to collaboration with artists interested in the political ramifications of an information world, to sites such as 360degrees.org, which uses Flash for the interface leading to a larger documentary project about the history of incarceration that incorporates animation, live-action interview footage, photographs and text. Rather than designating a formal style, then, Flash and Shockwave are now tools employed toward incredibly divergent ends.

Taking the episodic animation format one step further, San Francisco-based filmmakers Syd Garron and Eric Henry worked in collaboration with DJ Qbert to create a long-form visual complement to the DJ's celebrated album *Wave Twisters*. The 45-minute animated film was made using Adobe After Effects, and follows the album's track-by-track narrative with a story about the Inner Space Dental Commander, whose task is to revive the elements of hip-hop culture by battling innumerable villains in a dense, visually excessive 'inner space'. The filmmakers tried to create a visual corollary to turntablism, mixing disparate visual and animation styles at will. Similarly, the band Daft Punk collaborated with Japanese animator Leiji Matsumoto to create *Interstella 5555: The 5tory of the 5ecret 5tar 5ystem* (2003), based on the band's 2001 album *Discovery*. A dense, dazzling conjunction of sounds and images, the film illustrates the potential of the collaboration between musicians and filmmakers; rather than creating an illustration of the album, Matsumoto and Daft Punk instead find a point where the sound and image meet without hierarchy.

Travelling shots

While kaleidoscopic imagery, hybrid spaces and the graphic design and animated film are all prominent forms, shorts and music videos that chart traversals of space are also prevalent. In their use of graphics and fly-throughs, this group of videos may evidence the connection between art and the military most clearly. Indeed, the earliest computer graphics were reminiscent of radar screens, showing white dots on a black or green background, with the dots representing enemy planes, missiles or submarines. These early graphics had a specific intention: to be able to depict space as it was affected by the movements of the enemy. With the creation of the World Wide Web in the 1990s, computer graphics completed the familiar arc from military to commercial applicability, and have today become the most immediate enabler of the Internet's image-field of commodities and personal communication.

But there are other influences as well. The music that accompanies many of these traversals is frequently electronica, which in its own way seems to move through space. Writing about early music experiments, critic and historian David Toop explains that 'many of the first experiments in electronic and concrete music used transportation or physical movement as either theme or source material for sound constructions that were challenging the physicality and humanistic values associated with music production' (2000: 61). He goes on to quote composer Edgard Varèse, who imagined 'masses of sound moving about in space, each at its own speed, on its own plane, rotating, colliding, interacting, splitting up, reuniting' (ibid.). Nothing better explains many of the image correlates to this music: sound made visible, and careening through space, here often rendered as a datasphere or a fantasy geography that allows unprecedented mobility.

In their reality-defying movement, however, these videos also exhibit utopian tendencies. According to theorist Louis Marin, utopian representation 'always takes the figure, the form, of a map'. The point of view depicted in these videos has no body; it transcends boundaries, borders and frontiers, seamlessly traversing entire worlds to create a new form of visual pleasure and a mobile gaze that cannot be stopped. Once again, this particular gaze is linked to more nefarious technologies – but it also affords a vertiginous pleasure.

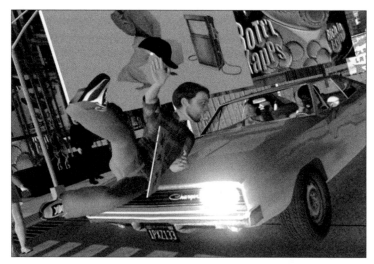

FIGURE 8 *Mashin' on the Motorway* (2003) by Ben Stokes and Doug Carney

In 'The Sound of Violence' (2003), a video made by Alex & Martin (the moniker for French directors Alexandre Courtes and Martin Fougerole) for a track by Cassius, it feels as if we are soaring across the world, through tree-filled forests, across grassy fields and finally over a landscape rife with very odd, large and colourful worms that wind their way up and down through terrestrial holes. Michel Gondry's 'Joga' (1997) starring Björk, too, releases the camera to zigzag effortless over digitally generated landscapes, while 'Mashin' on the Motorway' (2003) by Ben Stokes and Doug Carney for a DJ Shadow track, employs the *Grand Theft Auto* game engine to depict the point of view of the driver in a car, careening through the streets of a computer-generated city in one example of a growing body of machinima films.

In each of these instances, the camera cuts loose from the technology that in the past would have grounded it, moving freely through imagined worlds and creating a sense of utopian freedom. A sense of exhilaration and freedom accompanies these projects, and indeed, the logical next step is the incorporation of this simulated footage with rides in theme parks, where the visceral visual experience can be augmented with other forms of technology to create an even more immersive, somatic experience.

Identity anxiety: seeing, being, becoming

In the final category of frequent video tropes, attention shifts from a formal quality to a thematic one, namely the role of the body in an evolving technosphere. Indeed, an underlying question in many recent projects concerns the ways in which the body, including the observing body, is becoming a component of new machines, economies and apparatuses, whether social, libidinal or technological. Jonathan Crary formulates the question succinctly: 'In what ways is subjectivity becoming a precarious condition of interface between rationalised systems of exchange and networks of information?' (1990: 2). He adds: 'Problems of vision then, as now, were fundamentally questions about the body and the operation of social power' (1990: 3). The question is answered frequently by pointing to the ability to duplicate bodies, to take individuals and replicate them endlessly. Beyond being a nifty digital technique, the repetition points to anxieties about identity, which is now grounded in information, and in turn exists across innumerable invisible databases. Hence, in a film such as *Copy Shop* (2001) by Austrian filmmaker Virgil Widrich, the multiplication of a hapless copy shop employee has dire consequences, leading to his ultimate demise. And in Michel Gondry's 'Come Into My World' (2003), the proliferation of versions of Kylie Minogue again suggests the ability to craft and commodify the pop singer as easily as one presses records.

Web cinema

While many of the design shorts, animations and music videos noted above appear online, there is yet another category of moving image artwork that needs to be recognised, namely 'web cinema'. Two of the first outlets for web cinema were The New Venue, started by filmmaker Jason Wishnow in 1998, and The Bit Screen, founded by Nora Barry also in 1998.[2] Both sites were dedicated to showcasing films made specifically for the Internet, and both founders were interested in investigating ways in which the particular attributes of the web would influence moving images.

In her essay 'Telling Stories on Screens: A History of Web Cinema', Barry notes the key differences between web-based cinema and traditional cinema: web cinema generally entails a solitary viewer, often seated at a desk, looking at a small screen rather than a viewer in an audience

looking upward at a large screen; web-based films tend to be short; the stories are clear, and often exhibit an individual voice and are often personal; the stories need not necessarily be confined to a single narrative structure. 'The technology allows for a number of narrative possibilities, including interactive and random configuration', notes Barry (2003: 545). She goes on to list a series of trends in storytelling, which include stories that borrow their episodic structure from television, the 'pass-along narrative' (in which a filmmaker starts a story, posts it online, and it is added to by other filmmakers), and interactive storylines. She also highlights visual trends, which include line drawings, painterly images and photographic work.

The work of filmmaker Maya Churi illustrates one direction of early web-based cinema. In her project *Letters From Homeroom* (2000), Churi uses letters that she had written and received while in high school as the basis for a screenplay with 17 scenes in which two sophomores, Alix and Claire, go through the daily travails of boyfriends, teachers and other high-school dilemmas.[3] Churi then shot a short film based on the script, but realised that the film would only have limited exposure, most likely on the film festival circuit. To reach an audience of teenagers, Churi would need to somehow put the material online. She subsequently decided to use the footage in an Internet-based project, and thus taught herself basic web design, and, using the high-school building as an interface, created an interactive story that allows visitors to investigate Alix and Claire's lives in the various spaces of the high school. Mixing live-action footage, sound and text, the project allows viewers an array of options for finding out more about the characters; the site also allows viewers to respond directly. *Letters From Homeroom* is just one of many divergent directions taken by filmmakers interested in exploring the web as an exhibition venue.

The work of Italian painter and filmmaker Andrea Flamini offers another direction. While the artist has more recently become known for an array of projects within the realm of database or computational cinema, in which he creates the possibility for generative narratives based on random sequences of sounds and images, he describes his web-based piece *Waterdream* (1998–89) as a 'web-based, multi-path movie divided in several episodes published sequentially over the period of one year', and indeed, *Waterdream* is a beautiful poetic narrative that allows users to choose different paths thought the story.[4]

With The New Venue Wishnow hoped to expand the site's outreach to cell phone and PDA screens, and even launched a film festival devoted to short pieces made for the Palm operating system, to showcase on PDAs. Titled 'The Aggressively Boring Film Festival', the festival garnered more than fifty entries, some showcasing the limits of the format, with others hinting at the possibilities. Elka Krajewska's piece, *38 Seconds (Silence)*, for example, is a lovely experimental short seemingly inspired by the early avant-garde film experiments of Fernand Léger or Maya Deren, while Rodney Ascher's *Triumph of Victory: A Great Fall*, which shows the freefall trajectory of a pilot who has been ejected from his World War Two fighter plane, achieves a sense of depth and tension, despite the uneven visual quality and the small size of the screen's frame.

In 2000 artist Florian Thalhofer created the Korsakow System, which allows people with no programming experience to construct relatively complex interactive narrative projects, which can then be distributed and viewed online or on DVDs or CD-ROMs.[5] The title for the system derives from the Korsakow Syndrome, a condition of loss of short-term memory experienced by heavy drinkers. Thalhofer was interested in the stories told by Korsakow Syndrome patients suffering this sort of memory loss, as he found that they had tremendous storytelling prowess. Thanks in part to the Amsterdam-based media arts organisation Mediamatic, which holds frequent workshops designed to introduce artists to the Korsakow System, there are now numerous interactive web-based projects that push the boundaries of both traditional web cinema and interactive works.

While many of the experiments with web cinema were intriguing, and the potential remains for much further exploration, many artists have sought to explore their ideas for interactivity and narrative experimentation in DVD-ROM or CD-ROM formats, or in galleries and museums. In addition, it should be pointed out that web cinema forms only one small section in the much larger sphere of Net art, which expands well beyond both the issues of cinema and narrative to encompass a vast range of artistic practices, agendas and artworks.[6]

Live video

While digital technology has made video editing infinitely easier and faster, developing the ability to mix visual elements in real time the way DJs mix

audio has been proven to be a greater challenge. The available tools are often awkward, and there has been little sense of direct connection to the footage. In January 2004, however, Pioneer introduced the DVJ-X1, akin to the company's standard-setting CD mixing tool, the CDJ. However, rather than mixing sound samples, the DVJ allows artists to mix video samples from DVDs, using dual turntable-like controls. With its intuitive interface, the device promises to catapult VJ culture into new prominence.

The lack of practical tools did not prevent some of the first VJ artists from creating live visual mixes. While there is an extensive history of visual music precursors, including innumerable animators and filmmakers from preceding decades, a more contemporary VJ culture has its roots in the 1990s when the guerrilla media collective known as the Emergency Broadcast Network (Josh Pearson, Gardner Post, Greg Deocampo and Ron O'Donnell) used a specially designed 'telepodium' deploying television monitors, lasers and lights in live shows. Combining myriad video and sound feeds, EBN added several projectors and two video samplers (designed by Deocampo, who helped create the After Effects software) in order to improvise a sound/image mix during live performances. Invariably politically oriented, the EBN mixes are wild, humorous and satirical cacophonies of appropriated news footage.

In 1992, EBN released a 30-minute video compilation titled *Commercial Entertainment Project*, a dense collage of appropriated imagery with a mix of sound sources, including the pieces 'Behavior Modification/We Will Rock You' and 'Watch Television', and in 1995 released *Telecommunication Breakdown*, an enhanced CD. While EBN disbanded in 1998, the group's impact was immediate and lasting; not only did the group members contribute to the evolution of a larger culture jamming movement, they inspired video artists to consider live video mixing as a form of art unto itself. Further, rather than appearing as moving wallpaper designed to enliven a band's performance, EBN demonstrated that VJing could be political in orientation. In this context, EBN became the spokespersons for the radical potential of notions of distributed authorship, data sharing, image and sound appropriation, and an entire culture based on sampling from the excessive media flow around us and re-using images and sounds to our own ends. The issue was less about authorship, ownership and commodification, and much more about actively performing a media-based resistance to network-controlled news and corporate culture.

Inspired by EBN, the Los Angeles-based VJ duo known as Animal Charm has continued along similar lines. Composed of Rich Bott and Jim Fetterly, Animal Charm began making single channel videos in the mid-1990s in Chicago. They had recently graduated from college, and upon discovering the films and curatorial work of Craig Baldwin and the discussion regarding copyright and Fair Use in his documentary film *Sonic Outlaws* (1995), they became increasingly interested in ways to take the imagery foisted on people and offer it back, through their own filtering and manipulation. The pair's first finished piece is *Sunshine Kitty* (1997), which mixes veterinary footage of cats with assorted other pieces of found footage. Using repetition, sound glitches and irreverence, the piece evolves into a surreal collage that is clearly rooted in everyday American image culture, but through Animal Charm's strange treatment, becomes an overdetermined and humourous limning of a larger American unconscious. In *Mark Roth* (1997), the pair joins footage showing the workings of the US Postal Service union with the music from *Airport* (1975) to create a hilariously hyperbolic drama. The finishing touch came when Nike tried to purchase the tape to use in its advertising.

Animal Charm eventually moved into live mixing when they realised that it was the chance combinations and juxtapositions of sound and image that intrigued them the most. However, their performances have always been adamantly low-tech, employing low-end video mixers, switchers and audio samplers that allow the pair to mix different sources of audio and imagery at will. With a continued penchant for industrial footage and animal-based videos, many of which are culled from yard sales, thrift shops and even dumpsters behind local production houses, Animal Charm's mixes are less overtly political than EBN's, and yet their refusal to abide by copyright restrictions aligns them with a larger culture jamming media coalition determined to undermine the corporate ownership of sounds and images.

Members of the British collective The Light Surgeons, founded in 1995, are similarly inspired by the process of scavenging, sampling and recombination. However, the emphasis in their performances, which have accompanied disparate bands, including Bentley Rhythm Ace and the Propellerheads, is to transform traditional music spaces into image-rich environments with innumerable projectors and images. Likening their creative process to hip-hop and the disassembling of beats and

rhythms and then recombining them into new sounds, the members of The Light Surgeons work like a band, jamming together with light as their medium.

The design firm Tomato has also played a key role in an evolving sound/image combination, culminating in 2003 with the release of the experimental game title for PlayStation2 titled *wordimagesoundplay*, which takes graphic cinema, music and gaming to a new level. Underworld, a band composed of Tomato designers, originally included Rick Smith, Karl Hyde and Darren Emerson (until Emerson left in 2000), is another manifestation of the music/design intersection. Indeed, Underworld/Tomato had already made a mark with the 1999 DVD release titled *Everything, Everything*, which allowed users to create their own combinations of performance footage by Underworld and text and video images designed by Tomato, in a sense allowing viewers to act as their own VJs.

Hexstatic is another key team – the London-based Stuart Warren-Hill and Robin Brunson created the images that accompany Coldcut's 'Beats and Pieces' and 'Let Us Play', and also created the 'audio visual album' *Rewind*, which showcases the pair's sampled images, but adds their own sounds, too.

VJ techniques are extremely varied, from the adamantly low-tech style epitomised by Animal Charm, to much more elaborate and sophisticated light shows. The tools, too, vary and include VidVox Prophet, a QuickTime video sampling program that works with a MIDI keyboard with video clips assigned to each key. VJamm, created by Coldcut members Jonathan More and Matt Black, allows users to mix sound and images with equal ease. The software was released in 1999, and eventually earned a place in the American Museum of the Moving Image's permanent collection. Beyond the differing tools and styles, the impetus remains the same: to be able to mix imagery quickly, fluidly and immediately, without the delays or the awkwardness introduced by computers, software applications or evolving hardware, and speaks to the intersection of moving image and sound art, in which more musicians are creating moving images, and more filmmakers are creating music. The cross-pollination of interests and tools has resulted in an explosion of new work, much of it hovering at the intersection of music and video and a reinvention of the longstanding tradition of visual music.

In short

While all of the films and videos mentioned so far in this chapter are relatively recent works made by emerging directors, a handful of filmmakers known for their contributions to American avant-garde cinema have recently turned to digital video, with astonishing effects, often pushing the spatial experimentation of younger artists in startling new and sophisticated directions. Leslie Thornton's *Peggy and Fred* compilation, for example, stages the collision of film and video, embodying formally the ways in which the competing forms speak to different needs and visions of the world.

The *Peggy and Fred* project began in 1985 when Thornton joined imagery of the two lone children of the title with masses of found footage. The resulting black-and-white amalgam traces a journey through time, space and media as the children improvise narrative vignettes, relate anecdotes, sing songs, cavort and fight, all the while wandering through a dystopic wasteland rife with the fuzzy screens of TV sets and the rusty remnants of old, abandoned cars. Thornton is a magisterial composer of sound and image, fusing the peculiar worlds of her two bumbling subjects with crazily haphazard footage, which includes workers on assembly lines, ducks looking in the same direction in unison, light sparkling on water, a milk drop splashing in slow motion, and dozens of other seemingly mundane selections of antiquated imagery. Fully indoctrinated into American culture, the children are pure reflection, bouncing layers of media back at us – every syllable they utter has originated somewhere else first, before it is sifted through their psyches, then into the more anonymous footage, finally creating what Thornton has dubbed 'culture as fiction'. Every sequence in the project commands attention, not just conceptually in order to weave connections among zigzagging ideas, but aesthetically, as viewers rush to savour the frequent, errant swerves into the gaping hole of nothingness. *Peggy and Fred* mixes film, video, text and voice-over in an exhilarating low-tech collage that transforms narrative time into narrative space; the short becomes a treatise on the slippery slivers of space that characterise contemporary existence.

Perhaps most surprisingly, Ernie Gehr, whose film *Serene Velocity* forms the foundation for this chapter, has in his more recent projects experimented with digital video as well, but both his films and his videos

illuminate the changing qualities of digital spatial epistemology. Like many of the short videos noted above, Gehr's film *Passage* (2003) was shot from an elevated train, in this case a train moving through former East Berlin. Gehr captures images of crackled brick buildings, sagging power lines and flaking graffiti, and the thump, thump, thump and occasional screech of wheels on train tracks. Through uncanny editing, Gehr transforms the otherwise mundane footage into a dazzling symphony of sliding, pulsing frames, creating a literal passage through space, and a metaphorical one through history. Despite the criss-crossing sequences of planar motion, Gehr maintains a stable horizon line to hold things in check.

In his 2001 video *Glider*, however, Gehr shifts gears and media. The horizontal stability of *Passage* vanishes and the camera cuts loose, rising up and away from the earth in vertiginous flight and then swooping gracefully through space to capture voluminous clouds, frothy waves and the distorted, flattened planes of buildings splayed out across a seemingly vast topography. With its disembodied camera and depiction of visceral, fluid flows of imagery captured inside a seaside camera obscura in Northern California, the video expresses an essentially digital experience of motion, filtered through two radically divergent technologies of vision.

Taken together, the works mentioned above continue the interrogation of space inaugurated in the early 1970s, at the moment of the creation of the Internet and its seemingly boundless information space, as well as the shift from modernity to postmodernity. These videos also continue the investigation of space begun in avant-garde filmmaking, continuing the interest in a graphic cinema, a psychedelic cinema and the creation of a mobile spectator. Finally, they embody and literalise our relationship to the world today. They hover at the intersection of globalisation, the emergence of new information technologies, and the breakdown of the traditional nation-state in an era of postmodern cultural production.

More specifically, these works map our contemporary world for us. In his book *The Image of the City*, writer Kevin Lynch shows how the ability to map, from memory, the spaces in which we live corresponds directly to our feelings of either belonging or alienation, and by extension, our sense of political engagement and empowerment. But the ability to map our world has grown increasingly complex with the rise of tremendously powerful transnational corporations, unbridled competition and the unrestrained pursuit of self-interest. How do you 'map' a global economy, a vast military

complex, or the convergence of gigantic corporations? How do you chart multinational banking and stock exchanges, or the increasingly powerful web of bureaucratic control? These videos constitute the most compelling site for discerning the central issues that we face as a culture, and indeed, these rather disparate art practices offer a map, often literally but more often metaphorically, of our world.

3 IMMERSION AND EXCESS IN NEW VIDEO INSTALLATION

The third major strand in an evolving digital media landscape is video installation. Since 2000 the number of American and European galleries and museums interested in showing video art that extends beyond single channel pieces has expanded tremendously. Dazzling, large-scale projections by Bill Viola and provocative installations by Gary Hill, for example, tour the world, while the sharp rise in the presence of video in the major biannual shows in the US and Europe has sparked both enthusiasm and condemnation. It would be easy to read the entrance of these large-scale media installations as a means of drawing audiences back into these spaces with the spectacle of cinematic imagery. However, beyond this somewhat cynical explanation, video installation has also been heralded for its role as *the* artwork for our era. As Maggie Morse states, 'The "video" in video installation stands for contemporary image-culture per se':

> Each installation is an experiment in the redesign of the apparatus that represents our culture to itself: a new disposition of machines that project the imagination onto the world and that store, recirculate, and display images; and a fresh orientation of the body in space and a reformulation of visual and kinesthetic experience. (1998: 158)

Here Morse lists video installation's key elements: its foundation in an increasingly image-based culture; its insistence on the role of the body in the reception of the artwork; and its attention to the larger apparatuses of

image culture, from the staging of visual spectacle in the most pragmatic, even technical sense to the role of images in an increasingly corporatised art culture.

Video installation's focus on the body is not insignificant. The relationship between the body and technology has grown increasingly complex over the last decade such that to speak of one is to speak of the other. Body and machine become co-extensive, and yet the predominant trope for understanding the relationship between the two tends to presuppose a desire to be rid of the body altogether, or to view technology as a prosthesis. Borrowing Maurice Merleau-Ponty's notion of flesh as a tentative, shifting perimeter of the body, Amelia Jones argues for a 'technophenomenological' subject, one that is continually situated relative to the not quite locatable limit between the body and the world. For Jones, the technophenomenological subject is in a constant state of flux with the world around it and it is this subject conjured by many video art installations that attempt to reckon with the mutability of corporeal boundaries (1998: 206).

On the other hand, the seeming infinity of cyberspace, with its unending openness and indeterminacy, and the fact that travel 'through' cyberspace is bodiless, contribute to the nagging feeling that the body is an ungainly nuisance, which in turn prompts further anxieties about the role of the body. As Margaret Wertheim notes, 'When I "go" into cyberspace, my body remains at rest in my chair, but some aspect of me "travels" to another realm ... [W]hen I am interacting in cyberspace my "location" can no longer be fixed purely by coordinates in physical space' (1999: 41). Jonathan Crary seconds the notion, writing, 'Unavoidably, our lives are divided between two essentially incompatible milieus; on one hand, the spaceless electronic worlds of contemporary technological culture and, on the other, the physical terrain on which our bodies are situated' (2003: 8).

The reconfiguration necessary to reconcile this apparent quandary suggested by Wertheim and Crary is offered to some extent by Merleau-Ponty, who, despite having written his key essays in the 1960s, is often called on to support the importance of the inter-subjective nature of contemporary video installation. Writing about the installation works of Gary Hill, for example, Lynne Cooke notes:

> While granting the reality of the objective world, Maurice Merleau-Ponty nonetheless stressed that it is in the interactivity that occurs

between the perceptible physical object and the perceiving motile subject that consciousness is instantiated. Phenomenology thus proposes that the status of being is not an absolute condition but one that changes relative to changes in the experience of the real. (2000: 135)

Video installation, in the ways in which it calls attention to the process of movement, interaction and conscious engagement, offers a very clear instance of the sort of relationship that occurs to render consciousness in Merleau-Ponty's terms.

While it may be tempting to link video installation to the large-scale film projection events of the 1960s and 1970s, most critics instead understand it to be an extension of minimalism, body art, performance and conceptual art. This is not to say that there is no connection between film projection art and video installation; rather, the major interests of video artists as the artform took shape were not necessarily those of film artists, many of whom were intrigued by the creation of a shared image space described by Gene Youngblood. Instead, early video artists such as Bruce Nauman, Joan Jonas and Vito Acconci were far more inspired by video's liveness, and its capacity to record and project in real time.

In her essay 'Film and Video Space', curator Chrissie Iles argues that video installation can be broken into three stages. The first is a phenomenological and performative stage and refers to artworks that share minimalism's fascination with creating spaces within which a viewer engages with issues about the status of the artwork, the viewer, scale, space, institutions and so on. Just as minimalism was concerned with re-thinking subject/object relations, so too was video installation, wherein the artwork's status as an intersubjective process became paramount. The fact that video had the capacity to record and project in real time added to its centrality in this arena. The second stage is sculptural, in which video installation's concerns derive from sculpture and issues of space, form, shape and so on. Iles' final stage is the cinematic stage in which video moves away from intersubjective engagement to rekindle the awe of the cinematic experience, now transported to disparate, non-theatrical settings. In this stage, too, the moving image intersects with architecture to create new surfaces and planes that shift, augment or undermine traditional architectural space.

With digital imagery and a new generation's take on the form, video installation and its goals have evolved. To be sure, the works of artists such as Bill Viola, Mary Lucier and Gary Hill continue to fulfill certain expectations within the confines of the museum or gallery space. But younger artists are bringing their disparate backgrounds and influences to the form, incorporating, for example, the fast-paced cutting and pop imagery of music videos and television commercials as seen in the work of Swiss video artist Pipilotti Rist; an interest in spatialised narrative in the work of British filmmaker and video artist Isaac Julien; the focus on cinema as a source from which to cull imagery for the purposes of critical and aesthetic analysis as in the work of Douglas Gordon; the desire to take one discipline and reconsider it within the parameters of another, as with the work of Jeremy Blake, who brings notions of painting to his large-scale projection pieces; and a generally giddy fascination with images shown large, not within the narrow confines of the movie theatre but in open spaces that allow for movement, reflection and even conversation.[1] Pushing further, some artists, such as Rafael Lozano-Hemmer, are taking their projections out into the public spaces of city streets and plazas, while others are using projectors to create a form of digital graffiti.

While some video installation projects are merely resituated cinematic works that use the gallery or museum space to accrue high art status, many other installation video works share in the historical avant-garde's desire to disrupt the power of the museum by sparking insights that illuminate the contradictions implicit in creating a locus for art that is separate from the outside world. Installation art, by its very being, calls into question the location of art, if only in bringing to the foreground the space in which it is found, and the space the viewer needs to traverse in order to experience it. Indeed, installations often act as a space within which the negotiation of boundaries – between private and public space, or between art and the 'real' world – are made literal. The acts of perception, reception and movement are emphasised and the installation becomes, in Thomas Zummer's analysis, an interface, a device through which viewers negotiate differing spaces, as well as the cultural status of art production and interpretation (2001: 77).

While the world of contemporary video installation is a huge, sprawling artform, there are certain tendencies that are prominent. This chapter will consider the dominant practices of spatialised narratives, immersive installations, sculptural pieces and video projection in public spaces.

Spatialised narrative

Many stalwarts of video art abrogated narrative for more than two decades, but narrative has become a central issue in video installation art from the mid-1990s onward.[2] However, rather than duplicating the narrative expectations and paradigms of Hollywood cinema, video artists working in installation more often play with storytelling, trying at once to deploy its power while undermining its hegemony in a series of experiments that entail placing narrative within spaces, thereby upending the viewer's traditional role as a stationary receiver. In general, there are four discernible trends in the use of narrative in video installation.

Reduction and critique
Some artists reduce the components of narrative such that viewers are made very aware of just how little it takes to spark our desire to know more. We do not really need the elaborate trappings of a Hollywood film to become intrigued; the slightest hints of narrative will lure us into a story. Runa Islam's *Tuin* (1998), for example, re-enacts a short segment of Rainer Werner Fassbinder's 1973 film *Martha* and projects the scene on a screen suspended in the middle of a gallery space. The scene shows the intersecting paths of two characters at what Islam describes as a pivotal moment in Fassbinder's story. Islam restages the scene, and allows the camera to show the filmmaking apparatus while at the same time emphasising the 360-degree shot employed by Fassbinder. The power of the encounter between the characters remains, but it is received within a conscious recognition of the cinematic machinery. But the piece redoubles the spatial parameters of the shot by allowing viewers 360-degree access to the scene as it hovers in the gallery space; we encounter the image very differently in our ability to circle the screen, whether paralleling the movement of the camera or moving against it. The piece deftly supplies the power of narrative while also making viewers highly aware of its occlusions, but it also underscores the significant role of movement within the scene by allowing movement outside of it.

The ambient narrative
Inspired perhaps in part by the pacing and rhythmic cadences of electronic music, many artists have adopted an ambient form of narrative, with story-

telling moving along an even, horizontal plane, with repetition and varia-
tion being the primary organising principles, rather than the rising action
and inevitable forward thrust aimed at the closure of traditional narrative.
Los Angeles-based artist Doug Aitken, for example, has built a body of
work over the last decade which stages drifting stories within spaces in an
attempt to meld psychic and physical space, and in the process, to honour
the often meandering pace of consciousness. In *Electric Earth* (1999), for
example, a character wanders through the empty urban landscapes of Los
Angeles, feeling the pulsing, invisible forces of energy that flow through the
city, with his body responding in visceral ways. In *Blow Debris* (2000), sev-
eral characters who are nude inhabit a desert landscape; the brilliant blue
sky and sharply defined rolling hills of sand create a pastoral backdrop, one
disrupted by the hints of contemporary culture – piles of discarded televi-
sion sets, for example – and the distinct sense that many of the bodies are
all too-perfect constructs and, as such, not quite at home in the natural
world. There is a story here, but it drifts, seemingly aimless, offering a
decidedly leisurely counterpoint to the bustle of contemporary urban life.

While Aitken learned to shoot and edit moving images by making
music videos, and continues to make them on occasion, his installation
work tends to be unhurried, and his narratives ambient in nature. Further,
Aitken is very precise in how he stages the stories within the gallery and
museums that host his work. *Blow Debris*, for example, when showcased
at the Museum of Contemporary Art in Los Angeles at the end of 2000 as
part of a show titled 'Flight Patterns', was housed in three separate rooms,
each painted a different colour and each showing a different geographical
space from the story. Each room included a triptych of screens, dividing a
singular point of view into conflicting, disorienting perspectives, refusing
the pleasure and authority that comes with unity while at the same drawing
viewers almost viscerally into the space. But despite – or perhaps because
of – the vertigo of spaces, screens and viewpoints, Aitken's rendering of
the maëlstrom that blows through the liminal space between nature and
culture resonates strongly indeed.

The episodic narrative

Continuing the idea of the influence of television, but expanding to con-
sider the fact that we now take in more media than ever before, some art-
ists are creating narratives that are fragments, designed to be interpreted

or viewed sequentially. Vancouver-based artist Stan Douglas, for example, boasts a list of video-based projects that ruminate on places and the ways they are marked by history. His 1998 installation *Win, Place or Show* is set in an apartment that Douglas resurrected from a 1950s architectural plan designed to remedy urban decay in Strathcona, a poor area of Vancouver. The proposal entailed destroying existing buildings and constructing modern dormitories designed specifically for bachelor workers. In the resurrected apartment, Douglas places two men who vent their frustration by arguing with each other in a series of confrontations. These numerous looped conversations, all of which are about betting or taking chances, follow the same pattern, and culminate in physical conflict. The conversations are exhibited on a split screen – Douglas shot all of the scenes with multiple cameras, then divided the perspectives between two screens, dismissing the rules of spatial coherence dictated by traditional narrative cinema, and creating instead a fractured dwelling that manifests the split separating the two men. Their conflicts are repeated endlessly on the two screens, their sequence randomly determined by a computer; according to Douglas, there are over 200,000 possible sequences of viewpoints. While viewers may long to be absorbed into the conflict, our identification is perpetually frustrated, reiterating the disjunction felt by the two characters. In this case, then, the video installation confronts the serial format of television, offering a theoretically unending experience of thwarted narrative. As Peter Weibel points out, 'The narrative universe becomes reversible and no longer reflects the psychology of cause and effect. Repetitions, the suspension of linear time, temporal and spatial asynchrony blast classical chronology apart' (2002: 49).

Spatialisation
Some artists have opted to multiply the screens on which we view their videos. In some ways this is a comment on the proliferation of screens in our daily lives, as well as an attempt to suggest that a story no longer needs the boundaries imposed by traditional cinematic narrative, either in terms of spatial or temporal continuity, or in terms of a conclusive ending. Finnish artist Eija-Liisa Ahtila offers an apt body of work in this category, with a series of moving image installations that borrow heavily from the cinematic codes of melodrama but then complicate them with the use of scale and multiple screens.

Ahtila began her career as a painter, then, in the early 1990s, turned to film, studying in Los Angeles at the University of California and the American Film Institute. However, she describes the transition between disciplines as one that never quite took; she never settled on a single form, but instead hovers between the two, mixing and matching as needed. Ahtila generally shoots on Super 16, then blows the footage up to 35mm, and she showcases her work in multiple forms: large-scale split-screen projections and multi-monitor installations attentive to spatial organisation in galleries and museums, and old-fashioned screenings in traditional theatres. Whatever their eventual exhibition form, though, Ahtila's projects always have a story to tell, however elliptical. Indeed, her creative concerns centre on the relationships that evolve among image, story and space.

If 6 Was 9 (1995) is a triple-screen evocation of sex as seen through the eyes of several teenaged girls. Here, Ahtila's ability to choreograph imagery across both the terrain of a narrative and the multiple screens that showcase it is readily apparent; the unusual accounts take flight, lifting away from expectation and convention to become lilting traces of truth told with a rare respect for teenaged insight and experience. And while many filmmakers have willy-nilly decided to create installations out of their work, creating what Raymond Bellour has archly called an 'aesthetics of confusion', Ahtila's work dances, moving through space and across multiple screens with subtle grace.

In *Consolation Service* (1999), Ahtila charts the end of a relationship in a double-screen projection piece. We see a couple in therapy, and watch as they agree to dissolve their marriage. What ensues afterwards, though, pushes the story into the realm of the fantastic, propelling two hapless characters and their dreary sadness into myth; the abject pain of the most mundane event registers properly, hitting both high and low at once.

With each of her pieces, Ahtila pushes a little bit farther, limning a contemporary consciousness with an entirely contemporary medium. In *Love Is a Treasure* (2002), she tells the stories of five women who harbour individual psychoses, and while each episode borrows from case studies, Ahtila mixes reality and fantasy to create worlds that exemplify her characters' particular fixations. The psyche, in a sense, produces its own space. In the section of the project titled 'Wind', for example, a woman's anger takes form as blustery gusts of air that blow like a hurricane through her apartment. At one point, the woman drags a mattress across the cluttered

FIGURE 9 *Love Is a Treasure* (2002) by Eija-Liisa Ahtila

room and lays it across a toppled bookcase. An ensuing shot, showing her curled up on her makeshift bed in a room of total chaos, perfectly captures a state of resigned rage. In 'Ground Control', a teenager interprets certain sights and sounds as signs from extraterrestrials, while in 'Underworld', a woman hides under her bed, fearful of possible murderers. Ahtila honours the fears and anxieties of her female characters and indeed, lets us experience with giddy recognition their everyday realities, as strange as they may be.

Other filmmakers working with spatialised narrative include Isaac Julien, whose installation pieces include the three-screen narrative titled *Long Road to Mazatlán* (1999), created in collaboration with Venezuelan-born choreographer Javier De Frutos, and *Vagabondia* (2000), which also features choreography by De Frutos.

Overall, the narratives displayed in video art are often about space, fragments, and the abundance of meaning. Where Hollywood narratives tend to close things down, video art opens things up, dispersing meaning outward, both figuratively and literally, through the multiplication and dispersal of screens. Further, in disrupting narrative, video installation impedes its naturalised policing function – if traditional narrative, especially as it is embodied in the programmatic and prescriptive codes

of Hollywood cinema, tells us how to behave, video installations can, in some instances, offer a form that allows the questioning of those rules and norms.

The body in space: immersive installations

While narrative remains central in the installation work of many artists, phenomenological concerns regarding the body in space, and its connection to the image, also continue to resonate for video artists in the new millennium. Storytelling retreats, replaced by issues of immersion and the role of the mediated environment in relation to subjectivity. Paralleling the concerns of body art and the shift in conceptions of identity, video artists working in this realm create environments within which viewers engage with questions regarding perception, space, the body and, ultimately, their relationships to the construction of subjectivity. As Amelia Jones notes in her book *Body Art: Performing the Subject*, many body artists contributed to a new understanding of subjectivity, one as 'embodied rather than transcendental, as in process, as engaged with and contingent on others in the world, and as multiply identified rather than reducible to a single, "universal" image of the self', adding that this notion 'intersects as well with the revolutionary challenges to patriarchal culture and cold war ideologies of individualism by the civil, new left, students', women's, and gay/lesbian rights movements from the late 1950s onward' (1998: 197).

Somatically oriented video installations also dismiss or invert the hierarchies of form and content, mind and body, insisting on the role of the body in its interpretation of the world. Rather than valorising vision over and above the other senses, these projects attempt to disperse perception, creating spaces within which the body as an entire entity experiences the artwork. As Maggie Morse explains in her essay 'Video Installation Art: The Body, the Image, and the Space-in-Between',

the arts of presentation and, particularly, video installation are the privileged art forms for setting this mediated/built environment into play for purposes of reflection. Indeed, the underlying premise of the installation appears to be that the audiovisual experience supplemented kinesthetically can be a kind of learning not with the mind alone, but with the body. (1998: 161)

As Morse suggests, video installations allow for an embodied percep-tion, one cognisant of the interplay between the body, space and the image. Artists accentuate this interaction in numerous ways, using scale, for example, as well as multiple projections, the shadows of gallery visi-tors, the placement of screens and numerous other techniques for drawing attention to the very visceral experience of the viewer within the image space.

Artist Jeremy Blake, for example, creates what he calls 'moving paint-ings'. His moving image projects are in fact DVD projections of slowly shifting planes of luminous colour within which appear evanescent images that frequently evoke bygone eras; the images hover in and out of focus, creating a slowly turning flipbook of jumbled pop dreams and memories. Rather than aligning himself with a history of abstract film and video, Blake, who studied at the California Institute of the Arts between 1989 and 1993, insists that his work emerges from the world painting. And not just abstract painting, but also collage. Indeed, pop artist James Rosenquist is a frequent reference point, and it is easy to see in that artist's touted 'F-111', a colourful mash-up of pop and military iconography, connections to Blake's own work, which similarly crashes together disparate yet fre-quently beautiful images, catching viewers in the uncomfortable space of delicious pleasure and an unsettling experience of the uncanny. That said, while there are hints of clear images, most of Blake's work overall tends to be abstract.

Encountering one of Blake's projects is never entirely about absorbing the piece's entire expanse of references and meanings. Instead, the pieces invite reflection, and an almost dreamy acquiescence to the beauty of the colours and images. While there is much to glean from each of Blake's projections, the pieces, initially at least, feel much more visceral than intel-lectually contemplative.

Blake's most recent project is *The Winchester Trilogy* (2004), which is a trio of short animated film loops that are to be projected in a gallery space. They each centre on the Winchester Mystery House, the 160-room man-sion designed and inhabited by Sarah L. Winchester (the Winchester Rifle heiress) in San Jose, California, beginning in 1884; she continued creating the house almost non-stop for 38 years. The house is remarkable in that Winchester's goal was to create spaces to shelter the ghosts of those killed by the guns, while also warding off evil spirits through the noise and chaos

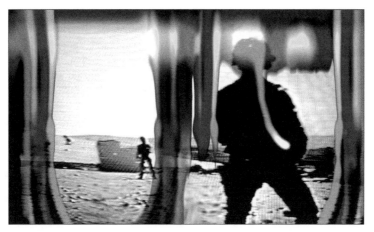

FIGURE 10 *Century 21*, from *The Winchester Trilogy* (2004) by Jeremy Blake

of construction and the design of uncanny spaces – the house includes stairways that lead nowhere and doors that open into nothingness. For the three-part project, Blake investigates differing aspects of the house, contemplating the links between Victorian culture and psychedelia, as well as the ways in which the spaces manifest trauma – Winchester experienced trauma, and her ongoing building efforts were, according to Blake, attempts to bury the trauma. Formally, the project starts on the outside of the house, then moves ever further inside, and then retreats to the outside and a trio of theatres situated just beyond the grounds of the mansion. Like much of Blake's work, the images are a meshing of colours, taken from the Super 8 footage that Blake shot in and around the house, as well as abundant pop imagery culled from the history of art, western films, gun paraphernalia and more, creating a moving image artwork somewhere between abstracting and collage.

Media artist Jennifer Steinkamp also creates projects that invite somatic contemplation. The Los Angeles-based artist makes large-scale, site-specific light and sound installations composed of projections of computer-generated abstract imagery. Entering a project that she has created is like walking into a virtual space rather than a concrete or real space. Steinkamp's interest in light and projection began in a class taught by Gene Youngblood. He introduced Steinkamp to the work of filmmakers

such as Ed Emshwiller and Oskar Fischinger, whose abstract work was an inspiration. However, Steinkamp added dimensionality to her own abstract imagery, using multiple projectors to alter the apparent contours of the spaces within which her works are viewed. Using light, then, Steinkamp 'dematerialises' architecture, creating illusionary spaces within real spaces. Further, as viewers move through one of Steinkamp's spaces, their shadows become interlaced with the projections, and their movements become part of the artwork itself. Because of the layering, however, one's shadow is never quite where it seems it should be, creating an uncanny sense of dislocation and disorientation. Thus, not only do viewers find themselves immersed in the images and sounds of one of her pieces, with the comprehension of – and trust in – the idea of solid, Cartesian space dissolving, but one's sense of somatic boundaries feels shaken, too.

Steinkamp's 1998 project titled *A Sailor's Life Is a Life for Me* offers a good example. Featuring pastel colours in the shape of waves washing rhythmically over the walls accompanied by the whoosh of water and the bleating of foghorns, the installation prompts an eerie swaying motion in response as viewers stand seemingly suspended in the layers of projected waves. With *They Eat Their Wounded* (2000), made in collaboration with Jimmy Johnson who created the audio, cubes made from flickering flashes of lightning dance and swing, making the corners of the gallery dissolve. And in *Jimmy Carter* (2002), huge fields of colourful flowers sway gently back and forth, prompting a similar sensation of spatial dislocation and dissolution of the boundaries between interior and exterior.

In creating her pieces, Steinkamp starts by mapping the actual space that she will be using; she then remaps that space into the geometric space of the computer. This creates an in-between space that Steinkamp can manipulate, establishing new spatial relationships within the architectural space. Light takes on attributes of physicality, becoming seemingly tangible. Steinkamp's interest in this transformation is not merely in creating sensations for viewers. She wants viewers to reconsider how we conceptualise our relationship with the physical world and with others. Also, the strict, binary divide between subject and object dissolves.

Many other artists are intrigued by the encounter between the viewer and the image. Gary Hill's large-scale pieces such as *Tall Ships* (1992), in which the movements of viewers within the gallery space trigger actions on large screens showing people, allow viewers to contemplate the image as

a seemingly sentient being. Several of Michal Rovner's pieces use multiple projections to create powerful image-suffused worlds. In *Time Left* (2002), featured in the Israeli Pavilion during the Venice Biennale in 2003, Rovner continued her exploration of the movement of groups of people – all four walls of a room bristle with the rustling of tiny people in row upon row, all of them marching inexorably from one wall to the next. The images initially look like barbed wire, and once you realise that the black figures are people, the comprehension of human futility descends heavily. Resolutely anonymous, the figures connote not just endless toil, but more specifically the movements of displaced people.

In each of these cases, artists create a direct confrontation between the body of the viewer and the image, establishing a degree of engulfment as traditional spatial coordinates give way to the image space. In other video installation pieces, however, the imagery is less overwhelming in its impact, relying instead on juxtaposition and the arrangement of multiple screens, requiring viewers to inhabit the installation space with the full recognition that their apprehension of the artwork is invariably partial, limited by the viewers' own physical limitations.

Shirin Neshat's multi-screen pieces fall into this latter category. Her dual-screen video installation *Fervor* (2000), for example, opens with a sequence of six shots: a man walks purposefully along a dusty dirt road, and a woman, dressed in a flowing black robe and veil, walks hurriedly along another road; they meet as their paths cross, exchange glances, the hint of a smile, and continue along, hastening to some place further ahead. The sequence, though, is doubled on the two screens, the woman on one screen next to the man on the other, creating a sense of symmetry with separation alongside asymmetry with convergence. Desire blooms in the flash of a glance and the brush of black fabric against imagined skin.

Neshat, who was born in Qazuin, northwest of Tehran, came to the US at the age of 17, when she entered the University of California at Berkeley and earned an MFA in painting. She eventually moved on to photography, then to moving images, and her work often entails multiple screens, which she uses to call attention to the role of the viewer in the creation of meaning. With *Turbulent* (1998), her first major moving image project, she divides the piece between two screens placed opposite each other. On one screen, a man enters an auditorium and sings a traditional song; when he finishes, on the other screen, a woman, dressed in the black chador worn

by Islamic women, begins to sing, eschewing lyrics in favour of passion-
ate, inchoate sounds that move from the deep tones similar to breathing,
to chanting and wild noises as the camera moves around her, swooping
in graceful circles. With her first project, Neshat was concerned with the
intersection of moving images and fine art, as well as issues of diaspora,
gender and radical cultural differences. *Turbulent* was followed by the
double-screen piece *Rapture* (1999), about the divergent movements and
reactions of a group of men and a group of women. Neshat is rigorous in
her choreography of images across multiple screens, and the viewer is
asked to decide what to watch, turning his/her body in response to curios-
ity, desire and interpretation. The multiple screens complicate one's ability
to view the entire piece; instead, viewers must choose, and in so choosing
acknowledge the partiality of the resulting interpretation.

While Neshat's pieces verge on being sculptural, her interest is directed
more toward establishing a hybrid form between art and cinema; as such,
her division of imagery across multiple frames makes literal the differing
points of view implicit in the production and post-production processes of
filmmaking, where differing shot set-ups offer differing images, and where
editing choices and the abutment of shots construes specific meanings.

The embedded screen: sculptural installation

Some artists are less concerned with the overwhelming scale or cinematic
qualities of the video image in a venue; instead, they direct their atten-
tion more assiduously toward the relationship of the video image to its
setting, underscoring the space as a stage that has been constructed
for the image. Monitors of all shapes and sizes are placed strategically
in constructed locales, or become elements within a larger assemblage
of parts. Los Angeles-based artist S. E. Barnet plays with notions of the
fragmented female body in *Mary Shelley's Daughter* (1999), for example, a
video installation that consists of nine video monitors arranged to suggest
the outline of a body. A humorous reworking of the Frankenstein monster
in more contemporary terms, the piece includes images of various parts
of the body on different monitors. Next to the configuration of monitors
Barnet includes a bookcase holding stacks of tapes so that viewers are
free to assemble different sorts of bodies at will, as if playing with a large,
mechanical paper doll.

In a different vein, Slovenian artist Natasa Prosenc situates projected imagery on or within objects – *The Pillar* (1997) examines the exterior of the body with a looping, rear-screen projection often shown on a tall pillar. The images show the intertwined limbs of more than one person; folds of bending elbows and the ripples of shoulder blades blend together becoming an amorphous human form that rolls forward, then backward. Similarly, Mona Hatoum's *Corps étranger* (1994) is projected on the floor inside a special circular booth; we see images of the artist's body, gleaned through cameras placed inside her through endoscopy, colonoscopy and so on. The piece relies on scale – the microscopic made large – and on the privacy of the viewing space, with viewers looking downward and experiencing a degree of vertigo. And in Tracey Rose's *TKO* (2000), a video projection hovers on a transparent screen, suspended in a small, dark room. The images show a woman (Rose herself, naked) as she pummels a punchbag in loops of rising and falling ferocity, with throaty grunts of exertion. Four cameras captured the original action, and Rose has layered the footage so that viewers see short video clips showing white walls, wisps of black hair and a dark-skinned torso simultaneously; the images are pale, translucent apparitions made more so by the see-through scrim on which they are projected. While the looped piece lasts several minutes, viewers never see within the ghostly collage a clear image of the artist, and the piece nicely stages the collision of anger, eroticism and invisibility and the fractious maëlstrom of racial and sexual identity; ultimately, however, it is the projection of the images on the suspended, wispy screen that gives the installation its subtle power, with the piece's formal, sculptural qualities embodying its theme.

In each of these cases, artists created a very specific space for their moving images, and in each, that construction relied on considering the exhibition space as a stage or setting, replete with props and very specific parameters. The moving image becomes embedded in a larger artwork, far removed from the television to which video is so often related.

The city as screen

Moving video images are increasingly finding their way outside, into public spaces as gigantic projections, interactive artworks and even digital graffiti. Perhaps the best known among artists working with video in public

space is Krzysztof Wodiczko, who has been projecting controversial images onto public buildings and official monuments for more than 25 years. Wodiczko, who studied in Warsaw, cites the work of Claude Lefort on public space as a site for contention and debate, and Chantal Mouffe and Ernesto Laclau's notion of antagonism, which allows for conflict and confrontation in understanding the fundamental construction of democracy, as ideas fundamental to his work. 'Public space is an enactment', he says in an interview with critic Patricia C. Phillips, and his projections are attempts to make the building exteriors embody the living, breathing inhabitants of urban spaces, while projections on monuments upset the 'official history' they are designed to represent (2003: 35).

Speaking of his earliest work with large-scale still image projects, Wodiczko says: 'I was interested in the architecturalisation of the body and the anatomical character of buildings' (2003: 44). As he continued, however, he became interested in adding the voices of people to the images. With *The Border Projection* (1988), for example, Wodiczko projected an image of a man whose hands are clasped behind his head, as if being arrested, onto the Museum of Man in San Diego and on the Centro Cultural in Tijuana, while *Tijuana Projection* (2001) shows the faces of women on the Centro Cultural, in conjunction with their voices, as they respond to the conditions under which they work, and to the projection itself. The conjunction of projected images and voices transforms the symbolic economy of the urban space, letting it tell an alternate story of suffering and struggle rather than one of triumph and power.

Using the term 'Relational Architecture' to describe his assorted projects, Rafael Lozano-Hemmer also uses public space in his projection-based artwork. In *Body Movies* (2001), Lozano-Hemmer projected photographs of people taken in the city where the piece is being exhibited/enacted; the portraits are shown, however, within the shadows of viewers, whose silhouettes then become the frames for the portraits of others. The movement of viewers in relationship to the projectors shifts the scale of both their own shadows and the portraits within the shadows, creating a sense of composited and performed social identity that is at once connected to and more than personal identity. With *Amodal Suspension* (2003), participants could send text messages by cell phone; these messages were then coded as a sequence of flashes that lit up the sky via twenty searchlights in Yamaguchi, Japan, where the piece was first shown. As Timothy Druckrey notes:

FIGURE 11 Rafael Lozano Hemmer's *Body Movies*, Relational Architecture 6, Rotterdam, Holland, 2001; photo by Arie Kievit

> *Amodal Suspension* visualises but does not create illusions, communicates but does not create narratives, bridges the links between networks (sites of non-located distribution) and frameworks (sites for located communication), and correlates the potentials for phone networks to be fully assimilated into computer networks as nodes whose presence and ubiquity are far more than a convenience and that can be rethought as a public space in which the exchange of messages is no longer privileged and imperceptible. (2004: 4)

According to Lozano-Hemmer, the term 'relational architecture' refers to the Mexican-born artist's desire to establish new forms of relationships among people and their surroundings by creating performative environments using projected imagery and light, as well as other forms of technology such as the web and cell phones. Because buildings assert a degree of power and control over public space – they stand for institutions, capital and national identity – they form the perfect backdrop against which to stage a series of interventions that allow people to participate not only in the interrogation of the stability of that power, but to imagine more open, engaged and mutable forms of public intervention and connection.

These projects also underscore the ways in which institutional power and authority are situated in a panoptic culture. At once invisible and the site of the gaze, disembodied power becomes, at least momentarily, the hard surface against which we can respond, not merely with tools of vision and imagery, but with the experiential negotiations of the borders between subject and world. Indeed, while their projects differ, Wodiczko and Lozano-Hemmer reflect the desire among many contemporary artists to create spaces for active public reflection.

While video installation is by its nature difficult to package and sell, and is most often temporary and challenging to document, it nevertheless performs one function within the confines of an institutional setting, and another when it moves outdoors into public space. This is not to say that 'public space' is only 'outdoor space'; as Patricia Phillips has written, 'The idea of the public is a difficult, mutable and perhaps somewhat atrophied one, but the fact remains that the public dimension is a psychological ... construct' (1998: 93). For both Wodiczko and Lozano-Hemmer, however, the idea of 'the public' as people interested in participating, however elliptically, in the creative questioning of the cities they inhabit offers a valid starting point. Further, their work relies on an insistence on video's role in fomenting communication rather than consumption. Writing about early video installation practices, Kathy Rae Huffman notes: 'The video medium was a statement against consumerism, against the art market, and toward a communication practice that involved community and consciousness' (1999: 137). That notion holds true for Wodiczko and Lozano-Hemmer nearly thirty years later.

As Lozano-Hemmer's projects reveal, with their inclusion of web-based tools, robotics and cell phone communication, video installation is not necessarily simply the creation of spaces replete with moving images; instead, artists are expanding in innumerable directions, incorporating computers, the Internet, virtual reality, databases, gaming technology and more into a sprawling practice that invites participants into 'electronic territories' and dataspheres. Again, to cite Huffman, from an essay published in 1994: 'Very seriously we must judge how [information technologies] affect our culture, our lives, our living' (1999: 139). She continues: 'As a working space, electronic architecture impacts our creative practices and physical reality – which certainly will bring about new social practices and observed realities' (ibid.).

4 AFTERWORD: THE DIGITAL IN THE MATERIAL WORLD

As I have tried to illustrate in the preceding chapters, cinema is in the midst of immense transformation, as are the fields of graphic design, music video, animation and other evolving forms of art that incorporate moving images. Beyond the areas described here, however, there are other burgeoning movements of moving image art, including Internet-based art and moving imagery created for PDAs and cell phones, alongside the huge groundswell of interest in gaming, which is quickly outpacing cinema in terms of revenue and vitality.

The impact of the expansion of moving imagery well beyond the confines of the movie theatre and television screens has only just begun to be analysed, not only in aesthetic terms, but in economic, political and social terms. Indeed, while the discussion here has focused on formal innovations and shifts, and their relationship to possible social reference points, it is necessary to consider the very material changes wrought by this evolution as well, despite the fact that so much of what we may be considering appears ephemeral or evanescent, and obfuscates its mode of production. The rapid production, use and disposal of hardware and camera equipment is only one among many very tangible results of the evolution of digital filmmaking, and like so much of the digital realm, tends to be concealed or forgotten in the forward rush towards newer, faster, more advanced technologies.

As Lisa Parks so graphically details in her essay 'Kinetic Screens: Epistemologies of Movement at the Interface', however, the discarded computers of one nation end up in another; using the research and

photographs of the Basel Action Network which depict the piles of un-recyclable computer waste in Guiyu, China, Parks make a strong case for First World accountability. She writes: 'In the global digital economy not all workplaces are filled with new flat-screen monitors, ergonomic chairs and colour laser printers ... Some are filled with cracked-open computers, separated scraps and scorched earth' (2004: 52). She goes on, noting that the inhabitants of Guiyu suffer the 'unequal and exploitative rela-tions between information rich and poor economies' and that their living conditions dramatise 'the way extraction is rearticulated in post-industrial economy as the commodification of obsolescence itself' (52–3). The tack taken by Parks has been taken by a host of artists as well, as they attempt to make evident the often invisible interfaces and screens of power that a digital culture masks.

As we experience an increasingly electronic manner of being in the world it is necessary to reckon with the material world too, a fact taken very seriously by many emerging artists intent on emphasising materiality via live performance and media hybrids, the incorporation of an activist agenda or an attempt to reckon with the politics of everyday life, espe-cially as it is lived far beyond the concerns of the First World. Sometimes this comes by slowing things down. In Craig Horsefield's video installation titled *El Hierro Conversation* (2002), for example, the artist creates an immersive sound and image environment dedicated to giving viewers a sense of life in the small village called El Hierro of Spain's Canary Islands. Shown on four large screens, each illuminating one wall of the square gal-lery and spanning nine hours and 17 minutes, the piece achieves a tempo-ral immersion as much as a spatial one, and for non-Spanish viewers who know nothing of its colonialist history, requires a degree of patience and willingness to experience the day-to-day minutiae of another culture. While not radically 'new' or particularly 'digital', the piece nevertheless partici-pates in a growing movement of video culture that attempts to contribute to a better understanding of the world around us.

The rejuvenation of activist media is yet another outgrowth of digital cinema, as is the proliferation of independent news centres worldwide and the establishment of alternate sources of information to counter the very narrow news flow allowed through corporately-owned outlets. In an era when news reports documenting a war prohibit the display of images deemed too dangerous for the American public, these alternate sources

are invaluable, although they remain too marginalised at the moment to be thoroughly effective. Again, though, the goal centres on making the intangible tangible, of using digital technology towards very material ends.

As so it should be on all sides; as we experience new forms of digital media, we are also being configured by new forms of digital media; and as much as we enjoy the power and freedom they offer, it behooves us to be cognisant of the systems of power and control that they allow over us as well.

NOTES

introduction

1 Peter Greenaway, speaking in Saas Fee, Switzerland, at the European
 Graduate School, August 2003. His comment is only one among many;
 indeed, when the Ampex Corporation announced the creation of the
 first videotape in 1956, the trades proclaimed, 'Film Is Dead!' More
 recently, Rob Sabin's feature on digital cinema in the 26 November
 2000 issue of *The New York Times* opens with a graphic showing a film-
 strip with the words 'The End' and 'Restart'. For a longer discussion of
 contemporary cinema's demise, see J. Lewis (2001) *The End of Cinema
 as We Know It: American Film in the Nineties.*
2 See V. Sobchack (2000) *Meta-Morphing: Visual Transformation and
 the Culture of Quick-Change.*

chapter two

1 Bill Moritz traces the history of early abstract visual music in his book
 Optical Poetry: The Life and Work of Oskar Fischinger (2004).
2 The New Venue: http://www.thenewvenue.com/; The Bit Screen: http:
 //www.nette.ca/bitscreen
3 *Letters From Homeroom*: http://www.lettersfromhomeroom.com
4 *Waterdream*: http://www.andreaflamini.com
5 The Korsakow System: http://www.korsakow.com

6 See Rachel Greene, *Internet Art* (2004) for an excellent history of Net art
 from the early 1990s to the present.

chapter three

1 Peter Weibel's concerns regarding the historical amnesia related to
 the history of projected art are pertinent here. See his extensive survey
 in 'Narrated Theory: Multiple Project and Multiple Narration (Past and
 Future)', in Martin Riesler and Andrea Zapp (eds) (2002) *New Screen
 Media: Cinema/Art/Narrative*, 42–53.
2 Narrative is also central to experiments in new media, as documented
 in innumerable books, including J. D. Bolter and R. Grusin (1999) *Re-
 mediation: Understanding New Media*.

FILMOGRAPHY

The list below is an idiosyncratic compilation of digital feature films that somehow advanced ideas about the possibilities afforded by digital film-making and desktop editing. The list, like the rest of the book, centres on independent and experimental projects rather than on the large-scale studio efforts, whose milestones have been chronicled elsewhere. The list is decidedly partial, and ends in 2003; that said, it should offer readers a helpful introduction to some of the key projects produced during the early days of digital experimentation.

The Book of Life (Hal Hartley, 1998)
Martin Donovan plays Jesus Christ and P. J. Harvey is his assistant Magdaena in this 63-minute black comedy shot by cinematographer Jim Denault. 'Rather than trying to make it look like film', Denault explains, 'we went the other direction. We wanted that *Wired* magazine, cyberpunk look.' Denault used an array of gels and filters, and he set the shutter speed of his DV camera at 15 frames per second or lower for the entire shoot. He also tended to shoot handheld rather than using a tripod or dolly. The result is a series of blurring, trailing images that help establish a new aesthetic direction for video.

Festen (*The Celebration*) (Thomas Vinterberg, 1998)
Thomas Vinterberg's *Festen* was the first official Dogme 95 film, and it initiated a worldwide interest not only in the Dogme 95 'Vow of Chastity' but in DV as a medium, thanks in no small part to the film's intensely

emotional story and its stunning cinematography by celebrated Director of Photography Anthony Dod Mantle. The story centres on a family reunion in which traumatic events from the past spark accusations and revelations during the patriarch's birthday dinner. The film was nominated for the Palme d'Or at the Cannes Film Festival in 1998, and won the festival's prestigious Jury Prize.

The Cruise (Bennett Miller, 1998)

The Cruise, director Bennett Miller's vibrant portrait of Timothy 'Speed' Levitch, is often touted as the film that legitimised the DV format, but more importantly, the film shows Miller getting to know, in a very personal way, an unusual character. The film's appeal is both in its subject, a New York City tour guide whose hyperkinetic verbal delivery and contagious love for the city are entirely compelling, and in the film's gritty, grainy and often beautiful imagery.

The Idiots (Lars von Trier, 1998)

The second official Dogme film, *The Idiots* considers the boundary between freedom and restrictions as a group of people 'spazz out' in public; von Trier encouraged an emotional honesty during production by shooting sections of the film while nude, and persuading the cast to perform without clothing as well. The controversial film is part of von Trier's 'Good Women' trilogy, but is perhaps most notable in its chaotic excess, and the intensity of the viewing experience for audiences.

The Last Broadcast (Stefan Avalos and Lance Weiler, 1998)

The story in *The Last Broadcast* follows four men who conduct a live broadcast for a public access television show, airing their story from the Pine Barrens of New Jersey. The goal of the journalists was to find the mythical beast called the 'Jersey Devil', but unfortunate events ensue, and two of the journalists wind up dead. According to Weiler, the filmmakers spent $900, shot 27 hours of footage, had 21 speaking parts, used more than 25 locations, and shot a lot of their footage at night. 'We didn't make any compromises', he says, adding, 'People who in the past have never had a voice for economic reasons will now be able to make movies.' The film was one of the first cut entirely on consumer level equipment, and it also has the honour of being the first feature film released theatrically via satellite

to theatres across the US. Finally, the film was also part of the Independent Film Channel's digital film showcase titled DV Theater, which offered a television and broadband 'simulcast' of the film. Following the simulcast, the film was available online for several weeks for download.

Modulations (Iara Lee, 1998)
Shot on a mix of digital and analogue video, Iara Lee's *Modulations* traces the history of electronica, from its genesis in the work of John Cage, through 1970s musicians such as Kraftwerk to the music of more recent creators. Lee did not just make a movie, however; she extended her project by publishing a collection of essays titled *Modulations: A History of Electronic Music – Throbbing Words on Sound*. She was one of the first digital filmmakers to imagine multi-platform projects that would extend beyond the theatrical experience.

Shucking the Curve (Todd Verow, 1998)
Working in a vein similar to that of Andy Warhol, filmmaker Todd Verow has made a series of miniDV feature films that revel in a low-budget cinematic excess. In *Shucking the Curve,* a young woman named Suzanne Fountain (Bonnie Dickenson) moves from a small town to New York City; her story is told with an appropriately frenetic camera. 'I'm trying to achieve a realism that I can't achieve in film', comments Verow, who adds that he tries to shoot in sequence as much as possible, and tends to shoot a tremendous amount of footage, sometimes with his crew consisting only of himself. Verow epitomises a prolific do-it-yourself, guerrilla style of filmmaking practice made even more viable by DV technology. Subsequent DV features by Verow include *Once and Future Queen* (2000) and *Sudden Loss of Gravity* (2000).

Better Living Through Circuitry (Jon Reiss, 1999)
In this colourful documentary, Jon Reiss examines rave culture of the late 1990s, noting that the small size of his DV cameras made him appear unobtrusive. 'The film reflects my own sense of exploration', says the director, who was able to glean candid interviews from his young subjects. This film, along with Iara Lee's *Modulations*, was among the first music-oriented DV documentaries, and Reiss, too, hoped to create a web extension of the film, including extra material for those interested in pursuing the topic further.

The Blair Witch Project (Ed Sanchez and Dan Myrick, 1999)
The Blair Witch Project is a pseudo-documentary following three film students into the Black Hills Forest in search of the mythical 'Blair Witch'. The filmmakers isolated their three cast members in the woods, guiding them with GPS technology, and shooting in sequence in order the capture the gradual decline of the actors as they grew increasingly exhausted. Thanks in part to the film's website, which was online long before the film was released and helped generate a fan base prior to the film's opening, *The Blair Witch Project* was a tremendous success, earning exponentially more than its production budget.

Buena Vista Social Club (Wim Wenders, 1999)
For *Buena Vista Social Club* German director Wim Wenders tagged along as Ry Cooder brought together Cuban musicians to record a CD. In addition to being a compelling document of musicians and their music, the film's high-profile director helped lend more credibility to DV as a format for serious filmmakers.

I Could Read the Sky (Nichola Bruce, 1999)
Based on a photographic novel of the same name, *I Could Read the Sky* traces the memories of an elderly Irish man's life as he recalls it in haphazard fashion from his lonely apartment in London. The film's use of abstract imagery, layering and elliptical editing creates a tactile rendition of memory; this was one of the first DV projects to attempt to create a poetic interpretation of the past.

julien donkey-boy (Harmony Korine, 1999)
Harmony Korine's second feature film was made within the guidelines of the Dogme 95 'Vow of Chastity' (the film is listed as number six on the 'official' Dogme register of films). Focusing on the story of a young schizophrenic played by Ewen Bremner, the film also includes Werner Herzog and Chloë Sevigny, and was shot by Anthony Dod Mantle, who creates one of the most dazzling colour palettes in any digital feature film.

Bamboozled (Spike Lee, 2000)
Mixing footage shot on miniDV and Super 16mm, Spike Lee's *Bamboozled* examines American racism in a satire about a television executive's

initially sarcastic attempt to skewer racist attitudes with a variety show titled 'Mantan – The New Millennium Minstrel', featuring two young black actors who don burnt-cork face paint to perform a series of dances and skits. Entirely missing the satirical elements, audiences make the show a hit, and the protagonist has to come to grips with the world in which he lives. In addition to its high-profile director, the film is significant due to its radical political edge, an edge that Lee felt he would not have been able to achieve in a more expensive project; shooting on miniDV and Super 16 allowed the director certain freedoms otherwise unavailable. The film also includes a stunning montage of racist depictions of black actors through-out the history of cinema in a sequence that deftly indicts American racism through its representations.

Chuck & Buck (Miguel Arteta, 2000)

Chuck & Buck achieved acclaim for eschewing the more dramatic visual flourishes of other significant DV films, showing instead the format's abil-ity to underscore the emotional intensity of a character-driven drama. The story follows the problematic relationship between two male friends who have grown apart since childhood. Director Miguel Arteta says he espe-cially liked how close-ups look in the digital format: 'They have a silky finish to them, making the story look much more immediate. We knew digital would work for *Chuck & Buck* because it's a very intimate character-driven story told mostly with close-ups.'

Conceiving Ada (Lynn Hershman Leeson, 2000)

Based on the life of Ada Byron King (the daughter of the poet Byron), who was credited with helping create the first computers in her collaboration with Charles Babbage in the 1840s, *Conceiving Ada* continues the pioneer-ing work of video artist and filmmaker Lynn Hershman Leeson, who has contributed a number of the most significant, and feminist, projects to the history of new media art. *Conceiving Ada* employed virtual sets and digital sound to create a fictive space for the characters; while this may not be an unusual practice for studio filmmakers, *Conceiving Ada* was produced on a budget of less than $1 million and suggested the creative possibilities of seemingly high-end digital technology for low-budget filmmakers. Leeson followed *Conceiving Ada* with another computer-based digital film titled *Teknolust* in 2002.

Dancer in the Dark (Lars von Trier, 2000)
With a stellar cast that includes Björk and Catherine Deneuve, and an emotionally draining melodramatic plot, *Dancer in the Dark* proved that miniDV could engage audiences on a visceral level. The frequently spectacular musical was shot with dozens of miniDV cameras, and while cinematographer Robby Müller was the Director of Photography, von Trier handled the camera for much of the shoot. According to Jason Kliot of Blow Up Pictures, '*Dancer in the Dark* is one of the true revelatory movies of the new millennium, where camera, eye and hand are mixed together in an extraordinary way.'

Everything Put Together (Marc Forster, 2000)
Before his hit film *Monster's Ball* (2001), Swiss-born director Marc Forster made the miniDV feature *Everything Put Together*, which he shot in 14 days. The story follows the growing isolation of a young mother after she loses her child. To illustrate her emotional state, the film moves from a traditional home video look to a more exaggerated, almost nourish style with unbalanced framing and unusual compositions; Forster also manipulated the colour in the footage extensively, explaining the differences between film and video by noting that 'if you work with watercolours, you're not trying to create an oil painting.'

I.K.U. (Shu Lea Cheang, 2000)
Reputedly designed to be a pornographic extension of Ridley Scott's *Blade Runner*, Shu Lea Cheang's *I.K.U.* features a difficult to discern plot about I.K.U. data collectors assigned to retrieve I.K.U. coders; both the collectors and the coders obtain information through sex, which offers the narrative foundation for the sci-fi film's innumerable and often ecstatic sex scenes. *I.K.U.* is significant in being an erotic art film, one which the director imagined being at the centre of a dense, multi-media environment that would include further extensions of the film on DVD and websites. According to Cheang, 'The film was totally made on a personal computer, and was influenced in part by my growing involvement with the Internet, and by the fact that I'm always interested in people's desires, including my own.'

TimeCode 2000 (Mike Figgis, 2000)
Setting out to create a 'virgin cinema', director Mike Figgis' *TimeCode 2000*

was shot with four cameras, all running concurrently and recording four divergent strands of a single story in real time. The narrative follows the sometimes erotic, sometimes ridiculous antics of several characters who begin in disparate parts of the city and eventually collide in the offices of a small production company in Hollywood. While all of the actors knew the basic elements of the story outline, they were encouraged to improvise, and thus the 97-minute performance of the film was extremely theatrical. Figgis pushed his experiment further, however, in showing all four camera viewpoints onscreen simultaneously; the screen is divided into four quadrants, with varying sound levels helping guide viewer attention. Figgis has 'performed' the film several times, mixing the sound live in front of audiences, directing and redirecting the course of the narrative into strikingly different combinations.

The Anniversary Party (Jennifer Jason Leigh and Alan Cumming, 2001)
The Anniversary Party is perhaps best known as the digital feature directed by actors. Jennifer Jason Leigh and Alan Cumming co-wrote and co-directed this star-studded story about the complexity of relationships, and reported an unrivaled ease on the set. 'The acting was the most effortless of anything I've ever been involved in', notes Leigh, adding, 'There was a kind of spontaneity and also a quick pace. It was very alive.' According to Gary Winick, founder of the production company InDigEnt, the film had a strong impact on DV filmmaking. 'People have never really seen DV movies with stars in them, and that's why *The Anniversary Party* is so important. We're not used to seeing Gwyneth Paltrow in a digital movie!'

The Center of the World (Wayne Wang, 2001)
In the NC17-rated *The Center of the World,* director Wayne Wang opted to use digital filmmaking tools to explore intimacy and eroticism. The video aesthetic references the gritty look of video and online pornography, but part of the reason for using digital technology was due to the intimacy afforded by the small cameras. The film received mixed reviews but pushed the boundaries of arthouse erotic fare in the US.

In Praise of Love (Jean-Luc Godard, 2001)
In his poetic reverie shot for the most part on the streets of Paris, Jean-Luc Godard mixes sumptuous black-and-white film with the lurid colours of

video, creating a startling contrast, and showing the depth and range of colour that can be achieved on video. While the narrative is elliptical, and includes the travails of a filmmaker trying to cast a film as well as a diatribe about Hollywood and history, the film's interest within this context is the disparity between film and video, and the beauty Godard achieves with the often disparaged format.

The King is Alive (Kristian Levring, 2001)

The fourth 'official' Dogme film, *The King is Alive* was shot in sequence over the course of six weeks on location in the Namibian desert. The story follows the plight of a group of tourists who become stranded, and decide to perform a version of *King Lear* to stave off despair and boredom. Speaking about the film, Peter Broderick, president of Next Wave, a company of the Independent Film Channel that offered finishing funds for digital features in 2000, notes: 'When people started out, the appeal of DV had mostly to do with budget. A lot of the first digital movies were quasi-documentaries. In the next stage, the assumption was that digital was good for intimate character pieces. But as people have seen different kinds of movies, our ideas about what's possible expand.' He was specifically refering *The King is Alive* which violated early rules of digital filmmaking which advocated avoiding bright sunlight.

The Lady and the Duke (Eric Rohmer, 2001)

According to director Eric Rohmer, the driving force behind the making of *The Lady and the Duke* was the idea of portraying Paris in the late 1700s. Confessing his frustration in watching period pieces, Rohmer opted to insert his characters into scenic backgrounds painted by Jean-Baptiste Marot. The film follows the story of Grace Elliott (Lucy Russell) and her relationship with Philippe, Duke of Orleans (Jean-Claude Dreyfus), during the French Revolution. Rohmer shot on DigiBeta, and started by filming the exteriors (extras, horses and carriages, and so forth). These were then keyed into the painted backgrounds, which were projected on to the floor by laser beam and then mapped with markers that would then guide the movements of actors. For exterior scenes, Rohmer composited the live-action shots of his cast members with Marot's paintings, creating images that almost appear to be moving paintings.

Series 7: The Contenders (Dan Minahan, 2001)
Director Dan Minahan's satirical skewering of reality TV and violence bor-
rows the conventions of a typical television series, with bumpers and inter-
stitials, to follow the doomed players in a game in which they must hunt
down and kill each other. Minahan shot on DigiBeta just as a television
documentary crew would, and tried to treat the production process as one
would treat a documentary shoot. The result is an episodic feature film that
bristles with the kinetic energy of a fast-paced reality show, with a healthy
dose of black humor.

Tape (Richard Linklater, 2001)
Smitten by the possibilities of shooting quickly and in small spaces, direc-
tor Richard Linklater set this feature film in a hotel room with a cast of
three. Cinematographer Maryse Alberti manages to keep the project visu-
ally compelling with a variety of camera angles and movements. This film
suggested the potential of stories occurring in real time in a single loca-
tion, with the cinematography, screenwriting and performances together
keeping the film alive.

Things Behind the Sun (Allison Anders, 2001)
For *Things Behind the Sun*, director Allison Anders ventured into her own
past to consider rape in a powerful drama that sadly never made its way
into American theatres. Kim Dickens plays a young singer haunted by the
past, and Don Cheadle plays her manager. Anders returned to the house
where she herself was raped as a teenager, and recreates the event with
a young cast, noting that the small cameras and their relative intimacy
allowed her to tackle the emotionally-wrenching scene. While uneven in
places, the film nevertheless manages to capture the dark underside of
violence in the flat, bright landscape of Florida.

Waking Life (Richard Linklatter, 2001)
To make *Waking Life*, director Richard Linklater collaborated with Austin-
based filmmakers Tommy Pallotta and Bob Sabiston; Sabiston had cre-
ated a proprietary software application that allowed him to animate over
live-action footage, and the pair had produced a series of short animated
documentaries, including *Roadhead*, *Snack and Drink* and *Figures of
Speech*. For *Waking Life*, Pallotta acted as the film's producer, and worked

with Linklater shooting the entire film on miniDV, and then editing it. Once the film was final, the footage was given to Sabiston, who worked with a team of 30 artists to animate the film. The result is an animated film that is at once very realistic in terms of movement and gesture, but highly impressionistic in terms of the manner in which each character is drawn. *Waking Life* suggested the viability of resurrecting the animated feature film for adult audiences.

Atanarjuat: The Fast Runner (Zacharias Kunuk, 2002)
Based on an Inuit legend, *Atanarjuat* was shot using the Sony DVW-700-WS, the first digital betacam to allow for a widescreen 16:9 frame. Production took place in the Arctic Circle, where temperatures would reach as low as -30 degrees Fahrenheit. Director Zacharias Kunuk made the film as part of the filmmaking collective Igoolik Isuma Productions, which also included Norman Cohn (a New York-based video artist), Paul Qulitalik (who plays a character in the film) and Paul Apak Angilirq (the screenwriter, who died of cancer prior to production). With its epic – and often gripping – story and stunning imagery, the film was not only an impressive example of the potential in shooting in bright light in wintry conditions, but also suggested the expanding potential of DV filmmaking for communities with little or no filmmaking experience. The film won the Cannes Film Festival's prize for best first film in 2001.

Full Frontal (Steven Soderbergh, 2002)
Explaining that he wanted a look that resembled Xeroxed images or footage processed in gasoline, director Steven Soderbergh made the DV/film hybrid project *Full Frontal* in part as an antidote to the larger Hollywood productions for which he has become known. 'I wanted to go out and shoot a film run-and-gun', he says. Designed as an extension of his first film, *sex, lies and videotape* (1989), the film was shot in 18 days with a $2million budget with a list of rules warning the film's A-list actors not to expect the usual Hollywood-style amenities. Soderbergh shot much of the film himself, and worked with the editors to cut the 50+ hours of footage on Final Cut Pro 3, finishing the film three weeks after shooting ended. While the film's story is not remarkable, the film's DV footage pointed to interesting aesthetic possibilities; Soderbergh's status also helped elevate miniDV as a format for serious filmmakers.

The Gleaners and I (Agnes Varda, 2002)
Agnes Varda's documentary is part personal essay and part political tract as the filmmaker explores the phenomenon of gleaning – picking up the leftovers, whether from fields where crops have been planted and harvested, or from the streets – while also considering her advancing age. Varda's film illustrates the potential of the digital medium in the hands of a thoughtful professional; it was one of the first essayistic DV films to receive a wide release.

Personal Velocity (Rebecca Miller, 2002)
Working with cinematographer Ellen Kuras, director Rebecca Miller chose three different aesthetic directions for *Personal Velocity*, which is based on a series of three short stories. Using two Sony PD150 miniDV cameras, the filmmakers illustrated an array of radically different looks that could be achieved, and indeed, the film won both the cinematography prize and the Grand Jury Prize at the 2002 Sundance Film Festival. 'I think there are great advantages and disadvantages to digital video', says Miller. 'I was able to use very long takes, sometimes 15 minutes at a time. And so I was able to keep the actors in an emotional space and not break their concentration.' This film is a great example of inventive and often beautiful DV cinematography.

Russian Ark (Aleksandr Sokurov, 2002)
Shot in one 90-minute uninterrupted take on 24P with the images stored on a hard disk recording system, *Russian Ark* is a technological feat, moving through an immense pageant that unfolds in the halls of the Hermitage Museum in St Petersburg. While the film occurs in a single take, it traverses history, reaching back to include the eras of Peter the Great and Catherine the Great, along with many other historical figures. Director Aleksandr Sokurov notes: 'I wanted to try and fit myself into the very flowing of time, without remaking it to my own wishes. I wanted to try and have a natural collaboration with time, to live that one-and-a-half hours as if it were merely breathing in ... and out.'

Tadpole (Gary Winick, 2002)
Gary Winick, founder of the New York-based DV production company InDigEnt, directed this coming-of-age story shot on miniDV and starring

Sigourney Weaver, Bebe Neuwirth and John Ritter. When asked how Weaver felt being photographed with a diminutive miniDV camera, Winick replied, 'I think one of the reasons that she wanted to be involved, beyond the script, was the possibility of working with DV and having the chance to act in this way. DV is very intimate and you can reorient the attention to where it belongs, which is on the acting.' *Tadpole* suggested that neither actors nor audiences were as concerned with image quality as studios and critics would have us believe; while the film is not aesthetically stellar, the story and performances make it a solid film worthy of viewing.

28 Days Later (Danny Boyle, 2003)
After shooting two short DV projects with cinematographer Anthony Dod Mantle (known for his work on *Festen*), director Danny Boyle enlisted Dod Mantle for *28 Days Later*, a post-apocalyptic tale about a group of survivors who try to escape the ravages of a deadly virus. The film is notable in that the DV cinematography heightens the grittiness of the world inhabited by the survivors and contributes to underscoring the fact that the narrative is set in the near future.

In This World (Michael Winterbottom, 2003)
Having shot *24 Hour Party People*, a chronicle of Tony Wilson, Factory Records and the Manchester music scene in the 1970s, on DV, director Michael Winterbottom returned to the format for his fictional feature tracing the journey of two refugees from an Afghan refugee camp in Pakistan to London. Winterbottom, working with a very small crew, shot on location, duplicating the voyage of his characters, and the film boasts a vérité style underscored by the DV imagery.

Pieces of April (Peter Hedges, 2003)
Starring Katie Holmes and Patricia Clarkson, *Pieces of April* is a gentle comedy about a family's struggle to deal with each other over the Thanksgiving holiday. While shot digitally, the film makes no fuss over its format, and indeed, aesthetic issues fade to the background, allowing the characters and performances to take centre stage. Like *Tadpole*, this film hints at a future 'digital invisibility', when the distinctions between film and video as a capturing format will be either unnoticeable or of little concern.

Tarnation (Jonathan Caouette, 2003)

Mixing video footage shot when he was an adolescent with more current footage, director Jonathan Caouette's *Tarnation* is a diaristic account of his dysfunctional upbringing in Texas. He traces the terrible struggles of his mother, who was given shock treatment as a young woman; she subsequently suffers mental illness, various forms of abuse and innumerable hospitalisations. Although Caouette is sent to live with foster families, he eventually reunites with his mother, and part of his documentary entails attempts to get his mother to remember the past. While much of this territory has been covered very effectively in the video art of the 1980s and 1990s, Caouette's low-budget handmade effort points to the increasing ease with which non-filmmakers can make compelling movies, thanks to desktop digital filmmaking tools.

BIBLIOGRAPHY

Arthur, P. (2001) 'The Four Last Things: History, Technology, Hollywood, Apocalypse,' in J. Lewis (ed.) *The End of Cinema As We Know It: American Film in the Nineties*. New York: New York University Press.

Bachelard, G. (1994) *The Poetics of Space*. Boston: Beacon Press.

Bazin, A. (1967) *What Is Cinema?* Vol. 1. Berkeley: University of California Press.

Beauviala, J.-P. and J.-L. Godard (1985) 'Genesis of a Camera (First Episode) in *Camera Obscura: A Journal of Feminism and Film Theory*, 13–14, 160–93.

Bellantoni, J. and M. Woolman (2000) *Moving Type: Designing for Time and Space*. Hove, East Sussex: RotoVision.

Betsky, A. (2001) 'The Age of the Recursive,' in *010101: Art in Technological Times* (exhibition catalogue), organised by the San Francisco Museum of Modern Art, March 3–July 8, 2001.

Binkley, T. (1993) 'Refiguring Culture' in P. Hayward and T. Wollen (eds) *Future Visions: New Technologies of the Screen*. London: British Film Institute.

Bolter, J. D. and D. Gromala (2003) *Windows and Mirrors: Interaction Design, Digital Art and the Myth of Transparency*. Cambridge, MA: MIT Press.

Bolter, J. D. and R. Grusin (1999) *Remediation: Understanding New Media*. Cambridge, MA: MIT Press.

Bukatman, S. (1993) *Terminal Identity: The Virtual Subject in Postmodern Science Fiction*. Durham: Duke University Press.

_____ (2003) *Matters of Gravity: Special Effects and Supermen in the 20th*

Century. Durham: Duke University Press.

Cooke, L. (2000) 'Postscript: Re-embodiments in Alter-Space', in R. C. Morgan (ed.) *Gary Hill*. Baltimore: Johns Hopkins University Press.

Crandall, J. (2002) *Jordan Crandall: Drive*. Ostfildern-Ruit, Germany: Hatje Cantz Publishers.

Crary, J. (1992) *Techniques of the Observer*. Cambridge, MA: MIT Press.

_____ (2003) 'Introduction', in N. De Oliveira, N. Oxley and M. Petry (eds) *Installation Art in the New Millennium: The Empire of the Senses*. New York: Thames & Hudson.

Critical Art Ensemble (2000) *The Electronic Disturbance*. New York: Autonomedia.

Cubitt, S. (1991) *Timeshift: On Video Culture*. London: Routledge.

_____ (1998) *Digital Aesthetics*. London: Sage.

_____ (2004) *The Cinema Effect*. Cambridge, MA: MIT Press.

Curran, S. (2001) *Motion Graphics: Graphic Design for Broadcast and Film*. Gloucester, MA: Rockport Publishers.

Curtis, H. (2002) *MTIV: Process, Inspiration and Practice for the New Media Designer*. Indianapolis: New Riders Publishing.

Darke, C. (2000) *Light Readings: Film Criticism and Screen Arts*. London: Wallflower Press.

Darley, A. (2000) *Visual Digital Culture: Surface Play and Spectacle in New Media Genres*. London: Routledge.

Dolphin, L. and S. Shapiro. (2002) *Flash Frames: A New Pop Culture*. New York: Watson-Guptill.

Druckrey, T. (ed.) (1996) *Electronic Culture: Technology and Visual Representation*. New York: Aperture Foundation.

_____ (with Ars Electronica) (1999) *Ars Electronica: Facing the Future*. Cambridge, MA: MIT Press.

_____ (2004) 'Real Telepresence...' Receiver #09, January, online at http://www.receiver.vodafone.com/09/articles/pdf/09_01.pdf

Everett, A. and J. T. Caldwell (2003) *New Media: Theories and Practices of Digitextuality*. New York: Routledge.

Feineman, N. and S. Reiss (2000) *Thirty Frames Per Second: The Visionary Art of the Music Video*. New York: Harry N. Abrams.

Furniss, M. (1994) 'Reconciling Art, Music, and Machinery: An Interview with John Whitney,' in H. Willis (ed.) *Scratching the Belly of the Beast: Cutting-Edge Media in Los Angeles, 1922–94*. Los Angeles: Filmforum.

Gere, C. (2002) *Digital Culture*. London: Reaktion Books.

Greene, R. (2004) *Internet Art*. London: Thames & Hudson.

Hall, P. and A. Codrington, J. Hirschfeld and S. Barth (2000) *Pause :59 Minutes of Motion Graphics*. New York: Universe Publishing.

Hamlyn, N. (2003) *Film Art Phenomena*. London: British Film Institute.

Hansen, M. (2000) *Embodying Technesis: Technology Beyond Writing*. Ann Arbor: University of Michigan Press.

____ (2004) *New Philosophy for New Media*. Cambridge, MA: MIT Press.

Hjort, M. and S. MacKenzie (2003) *Purity and Provocation: Dogme 95*. London: British Film Institute.

Hozic, A. (2001) *Hollyworld: Space, Power and Fantasy in the American Economy*. Ithaca: Cornell University Press.

Huffman, K. (1999) 'Video and Architecture: Beyond the Screen', in *Ars Electronica: Facing the Future*, T. Druckrey (ed.) Cambridge, MA: MIT Press.

Iles, C. (2001) *Into the Light: The Projected Image in American Art 1964–1977*. New York: Whitney Museum of American Art.

Johnson, S. (1997) *Interface Culture: How New Technology Transforms the Way We Create and Communicate*. New York: Basic Books.

Jones, A. (1998) *Body Art: Performing the Subject*. Minneapolis: University of Minnesota Press.

Kinder, M. (2002) 'Hot Spots, Avatars, and Narrative Fields Forever: Buñuel's Legacy for New Digital Media and Interactive Database Narrative', *Film Quarterly*, Summer, 2–15.

Knight, J. (ed.) (1996) *Diverse Practices: A Critical Reader on British Video Art*. Arts Council of England/University of Luton Press.

Krauss, R. (1999) '*A Voyage on the North Sea': Art in the Age of the Post-Medium Condition*. London: Thames & Hudson.

Lewis, J. (2001) *The End of Cinema as We Know it: American Film in the Nineties*. New York: New York University Press.

Lefebvre, H. (1974) *The Production of Space*. Cambridge, MA: Blackwell Publishers.

Liestol, G., A. Morrison and T. Rasmussen (2003) *Digital Media Revisited: Theoretical and Conceptual Innovations in Digital Domains*. Cambridge, MA: MIT Press.

London. B. (1995) *Video Spaces: Eight Installations*. New York: Museum of Modern Art.

Lovejoy, M. (1989) *Art and Artists in the Age of Electronic Media*. Ann Arbor: UMI Research Press.

Lunenfeld, P. (2000) *Snap to Grid: A User's Guide to Digital Arts, Media and Cultures*. Cambridge, MA: MIT Press.

Lynch, K. (1960) *The Image of the City*. Cambridge, MA: MIT Press.

Manovich, L. (2001) *The Language of New Media*. Cambridge, MA: MIT Press.

Mitchell, W. (1992) *The Reconfigured Eye: Visual Truth in the Post-Photographic Era*. Cambridge, MA: MIT Press.

MacDonald, S. (1993) *Avant-Garde Film: Motion Studies*. Cambridge: Cambridge University Press.

Moritz, B. (2004) *Optical Poetry: The Life and Work of Oskar Fischinger*. Bloomington: Indiana University Press.

Morse, M. (1998) *Virtualities: Television, Media Art, and Cybercultures*. Bloomington: Indiana University Press.

Mosco, V. (2004) *The Digital Sublime: Myth, Power, and Cyberspace*. Cambridge, MA: MIT Press.

Murphy, A. and J. Potts (2003) *Culture and Technology*. New York: Palgrave Macmillan.

Nash, Michael. (1996) 'Vision After Television: Technocultural Convergence, Hypermedia, and the New Media Arts Field', in M. Renov and E. Suderburg (eds) *Resolutions: Contemporary Video Practices*. Minneapolis, Minnesota: University of Minnesota Press.

Nash, Mark. (2002) 'Art and Cinema: Some Critical Reflections', in H. Ander and N. Rottner (eds) *Documenta 11: Platform 5* (exhibition catalogue). Ostfildern-Ruit: Hatje Cantz Publishers.

Ndalianis, A. (2004) *Neo-Baroque Aesthetics and Contemporary Entertainment*. Cambridge, MA: MIT Press.

Newman, J. (2004) *Videogames*. New York: Routledge.

Paul, C. (2003) *Digital Art*. London: Thames & Hudson.

Phelan, P., H. Obrist and E. Bronfen (2001) *Pipilotti Rist*. New York: Phaidon.

Phillips, P. (1988) 'Out of Order: The Public Art Machine', *Artforum*, December, 92–6.

____ (2003) 'Creating Democracy: A Dialogue With Krzysztof Wodiczko', *Art Journal,* Winter, 32–47.

Poster, M. (2001) *What's the Matter With the Internet?* Minneapolis, MN:

University of Minnesota Press.

Reiss, S. and N. Feineman (2000) *Thirty Frames Per Second: The Visionary Art of the Music Video*. New York: Harry N. Abrams.

Renov, M. and E. Suderburg (eds) (1996) *Resolutions: Contemporary Video Practices*. Minneapolis, MN: University of Minnesota Press.

Rieser, M. and A. Zapp (eds) (2002) *New Screen Media: Cinema/Art/ Narrative*. London: British Film Institute.

Rodowick, D. (2001) *Reading the Figural, or, Philosophy After the New Media*. Durham, NC: Duke University Press.

Rollig, S. (2001) ‹*hers*› *Video as a Female Terrain*. Vienna: Springer-Verlag.

Roman, S. (2001) *Hollywood Babylon: Hollywood, Indiewood and Dogme 95*. Los Angeles: Lone Eagle Press.

Rush, M. (2003) *Video Art*. London: Thames & Hudson.

Shaw, J. and P. Weibel (eds) (2003) *The Cinematic Imaginary After Film*. Cambridge, MA: MIT Press.

Smith, M. (2003) ‘Lars von Trier: Sentimental Surrealist’, M. Hjort and S. Mackenzie (eds) *Purity and Provocation: Dogme 95*. London: British Film Institute. xxx

Sobchack, V. (1990) ‘The Scene of the Screen: Towards a Phenomenology of Cinematic and Electronic Presence’, *Post-Script*, 10, 50–9.

____ (ed.) (2000) *Meta-Morphing: Visual Transformation and the Culture of Quick-Change*. Minneapolis, MN: University of Minnesota Press.

Solanas, F. and O. Getino (1997 [1969]) ‘Towards a Third Cinema’, in M. Martin (ed.) *New Latin American Cinema, Vol. 1: Theory, Practices and Transcontinental Articulations*. Detroit: Wayne State University Press.

Suderburg, E. (ed.) (2000) *Space, Site, Intervention: Situating Installation Art*. Minneapolis, MN: University of Minnesota Press.

Toop, D. (2002) ‘Life in Transit’, in M. Dávila (ed.) *Sonic Process: A New Geography of Sounds* (exhibition catalogue). Barcelona: ACTAR.

Trend. D. (ed.) (2001) *Reading Digital Culture*. London: Blackwell.

Youngblood, G. (1970) *Expanded Cinema*. New York: E. P. Dutton.

Wallis, B. (2001) ‘Judith Barry and the Space of Fantasy’, in *Judith Barry: Projections, Mise en Abyme*. Vancouver: Presentation House Gallery.

Wardrip-Fruin, N. and P. Harrigan (2004) *First Person: New Media as Story, Performance and Game*. Cambridge, MA: MIT Press.

Weibel, P. (2002) 'Narrated Theory: Multiple Projection and Multiple Narration (Past and Future)' in M. Rieser and A. Zapp (eds) *New Screen Media: Cinema/Art/Narrative*. London: British Film Institute.

Wertheim, M. (1999) *The Pearly Gates of Cyberspace: The History of Space From Dante to the Internet*. New York: W. W. Norton.

Winston, B. (1996) *Technologies of Seeing: Photography, Cinematography and Television*. London: British Film Institute.

_____ (1998) *Media Technology and Society: A History: From the Telegraph to the Internet*. New York: Routledge.

Zelman, S. (2000) 'Looking Into Space', in G. Swanson (ed.) *Graphic Design and Reading*. New York: Allworth Press.

Zummer, T. (2001) 'Projection and Dis/Embodiment: Genealogies of the Virtual', in C. Iles (ed.) *Into the Light: The Projected Image in American Art 1964–1977*. New York: Whitney Museum of American Art.

INDEX